IMAGES
of America

SUPERIOR AND
SOUTH SUPERIOR

D1604169

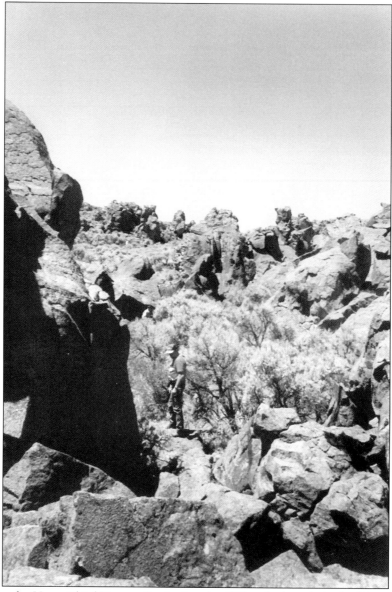

High above the Horse Thief Canyon lie the Leucite Hills, which include the Natural Corrals (above) and ice caves. This unique area is a favorite for picnics and camping, as water and shade are abundant. The Natural Corrals is on the National Register of Historic Places. The Works Progress Administration (WPA) described the area as a gigantic mass of rocks taking the form of corrals. They were said to have been a retreat for outlaws and horse thieves in the early days. Underlying these corrals are numerous passages and caverns, which contain ice year-round. (Courtesy of the Superior Museum.)

ON THE COVER: In 1943, the nation's highest honor for coal mine safety was awarded to the Union Pacific Coal Company's D Mine in Superior. The mine worked the year with 307,529 man-hours without a lost time accident. The miners are gathered for a picture celebrating the receipt of the Sentinel of Safety trophy. (Courtesy of the Sweetwater County Historical Museum.)

IMAGES
of America

SUPERIOR AND
SOUTH SUPERIOR

Frank Prevedel and the
Sweetwater County Historical Museum

ARCADIA
PUBLISHING

Published by Arcadia Publishing
Charleston, South Carolina

Printed in the United States of America

Library of Congress Control Number: 2010934471

For all general information, please contact Arcadia Publishing:
Telephone 843-853-2070
Fax 843-853-0044
E-mail sales@arcadiapublishing.com
For customer service and orders:
Toll-Free 1-888-313-2665

Visit us on the Internet at www.arcadiapublishing.com

To all those hearty settlers of Horse Thief Canyon who made exemplary lives for themselves and their families. This area's harsh environment bonded them together into a cohesive people. And to those who gave their lives in the mines; their great sacrifice helped build the nation.

CONTENTS

ACKNOWLEDGMENTS

The assistance of several individuals and organizations contributed to the completion of this book. Two individuals were especially helpful: Cyndi McCullers of the Sweetwater County Historical Museum (SCHM) and Margaret Arkle Bettolo of the Superior All-Class Reunion Committee. They were outstanding in their computer work and research and located and donated countless images. Thanks go to Ruth Lauritzen, director of the SCHM; Bob Nelson, director of the Rock Springs Historical Museum; Michalene Maes-Ekker, of the Town of Superior and the Superior Museum; the Wyoming State Archives; the University of Wyoming Heritage Center; the New Studio; and individuals Bob Lavery, Ray Lorenzon, Leno Menghini, Norma Lavery Jordan, Marcella Williams Romero, Wayne Korhonen, Flora Tosolin, Patty Hardy James, Ted Vallis, Dudley Gardner, David Kathka, Hannah Davis Tennant, and Sherry Tennant Pecolar. Thanks are also extended to Norma Prevedel and Iris Bonsell for researching images, tramping around the hills in the canyon, and encouraging me. Unless otherwise noted, all images appear courtesy of the Sweetwater County Historical Museum or the author.

INTRODUCTION

There are no better examples in Wyoming of the perils of dependence on the mineral extraction industry than Superior and South Superior. The twin towns lived a comparatively short life, with rapid settlement occurring in both towns with the opening of the mines, beginning in 1903 to 1906. They blazed a prosperous existence on the back of mineral development and then declined and decayed when demand for coal from the railroad dropped in the 1950s. This is a frequent tale of the West and especially of Wyoming's boom-and-bust economy. After beginning in the early 20th century, these two towns declined and nearly disappeared in the 1960s with the end of extraction of coal, which fed the locomotives of the Union Pacific Railroad. The railroad converted to oil to power its fleet. With the advent of the coal-powered electric generation at Pacific Power's facilities east of Superior, it seems that the decline has stopped, and the future looks brighter. The dependence on minerals begins anew, as mining at the Pacific Power plant and at Black Butte Coal provides the bulk of the jobs in the region.

In 1903, Morgan Griffith led a group of prospectors to Horse Thief Canyon to verify the development potential of known coal deposits. Preliminary exploration began in 1900 in order to start replacing older mines in the Rock Springs area, which were essential to feeding the locomotives of the transcontinental railroad. Thus, Superior and South Superior began with a settlement called White City. This name was appropriate because the men who were working for the prospectors lived in white tents. Sections of South Superior are still referred to as White City.

Superior was initially owned by the Superior Coal Company, which merged with the Union Pacific Coal Company in 1916. It consisted of coal camps that surrounded, or were near, mines bearing the names adopted by the camps. They were known as A Camp, B Hill, C Hill, and D Camp. In addition, independently owned mines and their accompanying camps were Copenhagen, Premier, and Superior-Rock. The town of Superior was incorporated in February 1911. The town of South Superior incorporated in March 1911. It consisted of the original townsite of White City and the Manning and McDonald additions, named for individuals who had homesteaded in the area. The towns were born two distinct communities: one was company owned, and the other was privately owned. Both depended upon the other for education, employment, religion, commerce, and recreation.

The map of the West is dotted with names like Virginia City, South Pass City, Almy, Poposia, Monarch, and Carbon, to name a few. These are western ghost towns. When the Union Pacific Coal Company went out of business beginning in the mid–20th century, several Sweetwater County towns headed for ghost-town status, as the company sought to get out altogether. It methodically sold buildings for removal or destruction. Winton and Stansbury disappeared as communities; so did Superior. On August 29, 1963, the town government passed a resolution dissolving incorporation. Its assets of $1,884.15 were handed over to the Town of South Superior. South Superior, because it was owned privately and not by the company, could not be destroyed. It was, however, badly hurt economically. Thus, the small village to the south was the cornerstone

for the future of people living in Horse Thief Canyon. In 1984, South Superior officially took the name Superior.

The peak population years were during World War II, when massive growth occurred because of the demand for coal. To ease the housing crunch, the federal government constructed apartment buildings, and the Union Pacific fashioned wheelless boxcars into living quarters. School enrollments during that time were high, but census counts missed the peak. As an example, in 1940, the combined population was 2,125, and the 1950 census showed 2,360, with 1,580 in Superior and 780 in South Superior. The school population at that time was half of the school count in 1944, so it is possible that the population of the two towns stood somewhere between 4,000 and 5,000 people.

When the Union Pacific closed its last mine in 1963, the population had dwindled. Census counts show 197 in 1970, but numbers were back to 586 in 1980. The 2000 census showed a population of 244. However, renewed life seems to be in the offing, with new homes being built as the result of available jobs and better transportation. The town had grown 37 percent in the 2010 census to 336 people. During the down period, it was not unusual to see homes on trucks being sent to Rock Springs and other locations. As a result, a good share of the Rock Springs population consists of former Superior residents or their descendents. New mines and mills for trona, a naturally occurring mineral, were opening west of Green River, which provided new employment for those who moved to be much closer to jobs.

When the mines opened in 1906 and thereafter, jobs were plentiful and people arrived from around the country and from foreign lands. It took courage to live in this barren and hostile environment situated at an elevation of 7,000 feet above sea level. But the mix created a population that shared a variety of cultures. First to come were the British, Welsh, and Scots, who were experienced miners recruited because of their knowledge and skills. Next, there came a virtual world of nationalities and ethnic groups. The largest group from Europe was from Finland, and Finns exerted a strong influence in politics and the world of work. Austrians, Tyroleans, Slovenians, Croatians, Czechs, Poles, Italians, Greeks, Irishmen, Mexicans, and others helped build the area. From the Far East, Japanese and Koreans came to Superior in large numbers. Eventually, the great American melting pot melded these people into one cohesive group with the common cause to raise their families to be good citizens. During this period, citizenship classes were thriving, and shortly thereafter, most newcomers became citizens who participated in the community. The production of coal was an imperative, as it provided the greatest source of energy to feed the industrial giant. The multinational population of Superior contributed to help meet the need. During World War II, the Union Pacific introduced yet another population into the culture, folks from the southern United States.

To those working in the mines, education mattered because their children would benefit from learning that would take them to occupations and professions less dangerous than mining. There was a demonstrated interest in and support for schools. That tradition continues. Today's population, which is young and vigorous and forward-looking, can glance back at what Superior was and know that what they offer is a new Superior.

The loyalty that former residents feel for the Horse Thief Canyon communities is renowned in the region, as demonstrated by the all-class reunions, which are scheduled every three years. It is a tremendous camaraderie that brings people from great distances to see the place again, to reminisce, and, hopefully, to meet and to know the new population that will make the place great again.

One

FINDING AND PRODUCING THE WEALTH FROM BENEATH

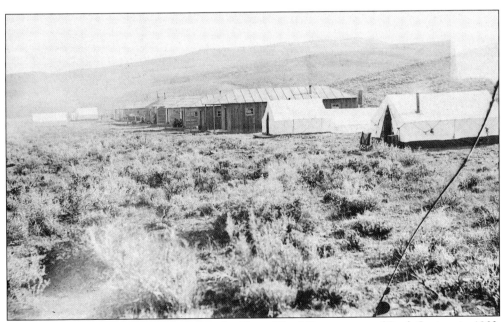

Prospecting for coal began in earnest in the Horse Thief Canyon east of Rock Springs in 1903. Those prospectors and early miners lived in temporary housing, including white tents. The first settlement was known as White City. Today, the business area of Superior and South Superior is still referred to as White City. This image features Camp B, which was located on level ground. Much of the later development was located on hills and on uneven terrain.

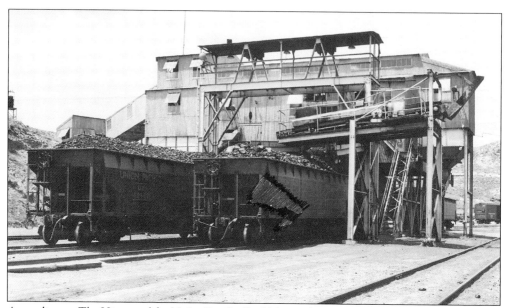

According to *The History of the Union Pacific Coal Mines*, the company in 1934 began searching for a new source of coal. It established the D.O. Clark Mine, named for the man who in 1874 was made superintendent of the mining department of the Union Pacific Railroad (UPRR). This mine, which the company said would furnish coal into the next century, was the most modern and productive of the company's sources and produced coal from 1938 until 1963. It was the last highly productive mine to close.

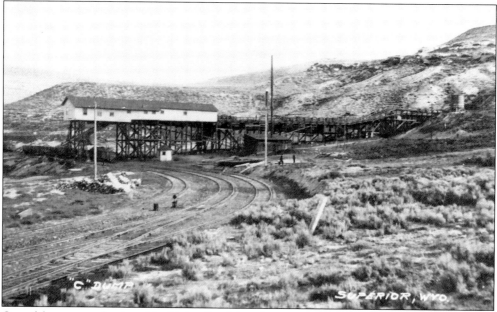

One of the most productive of the Union Pacific's early mines was C Mine, whose tipple stood nearly in the middle of Superior. Work began on the mine in 1903, and the slope into the excavation was created in 1906, the same year production began. Also, in that same year, A Mine and B Mine went into production. At the time, the newly founded community was known as Reliance, but on July 14, 1906, the name was changed to Superior by the Superior Coal Company.

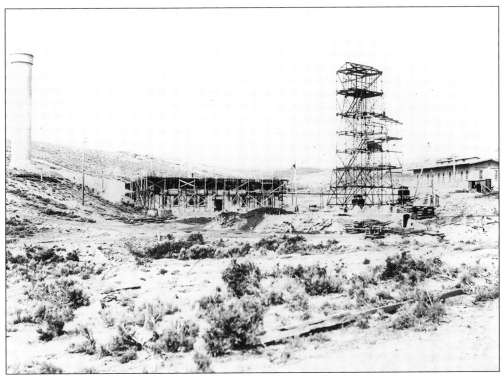

Production began accelerating with the construction of coal-loading facilities, called tipples, and generating plants, which provided the power needed to mine coal and to transport it to the surface. The Union Pacific's E Mine was completed in 1910 and produced power for the company's holdings. Its life was short, as it closed in 1937, and production shifted elsewhere.

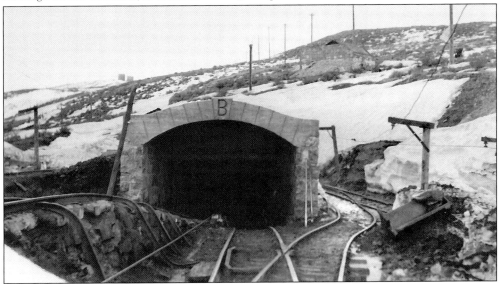

The mine entry portal looks rather formidable. The B Mine portal and the tracks for small production cars that pulled coal by cable from the mine were typical of slope mines. The coal was then loaded at the tipple into waiting railroad cars, and empty production cars were sent by cable back into the mine. A separate entryway, called a man way, was built for foot traffic.

11

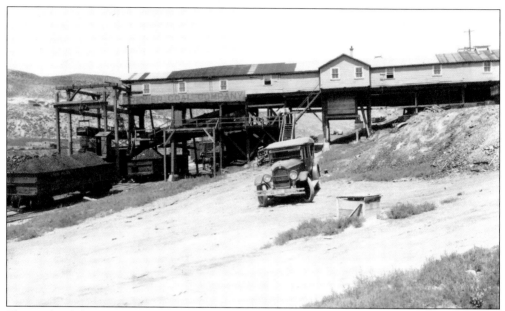

The tipple of the Premier Mine is an example of production of coal by an independent company not owned by the Union Pacific. Premier and its companion mine, the Copenhagen, were owned and operated by the Rock Springs Fuel Company. Each of the mines provided housing in a coal camp near the mine site. Production began in 1918 and continued into the 1950s.

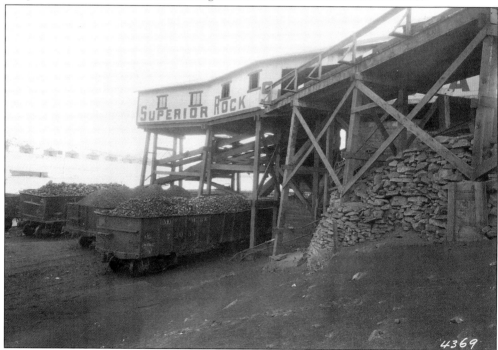

On June 1, 1917, the Superior-Rock Springs Coal Company announced the construction of a new mine in Superior to be called Superior-Rock. It was to be capable of producing 500 tons of coal per day. The company constructed 30 houses and expected to employ 80 miners. (Courtesy of the J.E. Stimson Collection, Wyoming State Archives, Department of State Parks and Cultural Resources.)

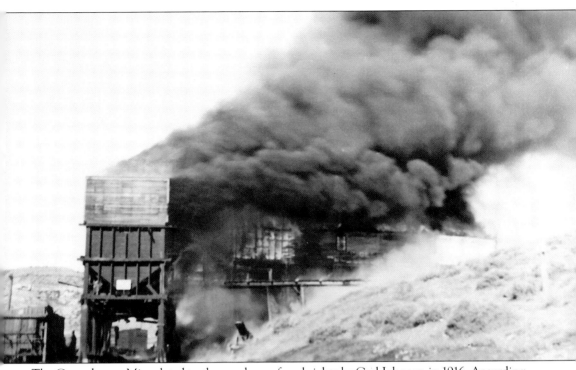

The Copenhagen Mine dated to the purchase of coal rights by Carl Johnson in 1916. According to a report by the state mining inspector, the mine began extracting coal in 1918. In 1922, coal and surface rights were sold to the Rock Springs Fuel Company, which operated the mine until the 1950s. On October 24, 1936, a spectacular fire broke out in the tipple, apparently caused by overheating belts and separators. A new tipple was constructed, and the company continued in business. Remains of the tipple can be seen today, fenced for preservation by funds from Abandoned Mine Lands (AML). On the day of the fire, a football game between Superior High School and Green River High School was in progress across the roadway. Soon, spectators abandoned the game to watch the blaze.

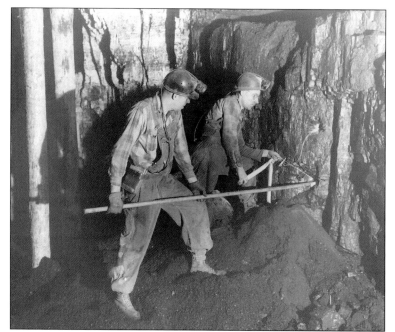

Once a coal face was ready to produce coal, explosive powder was placed in holes drilled into the wall. When detonated, the coal would fall and was ready for loading into small railcars pulled by cables to the surface or onto a continuous belt that went to the surface. Ed Overy (left) and an unidentified coworker are tamping powder into a drill hole.

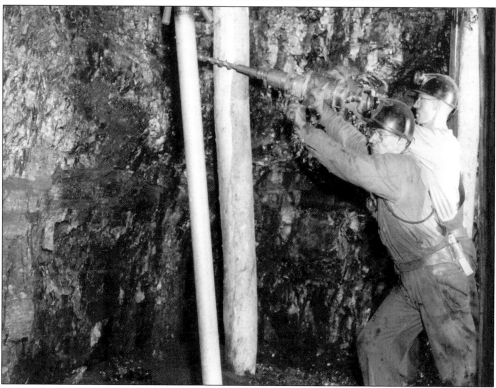

The drilling process required precise locations to provide maximum production by placing powder in strategic locations. Frank Prevedel Sr. (left) and an unidentified man are preparing to drill into the coal face. Timbers holding the mine roof are shown. Before electric power was available, drilling was done by hand.

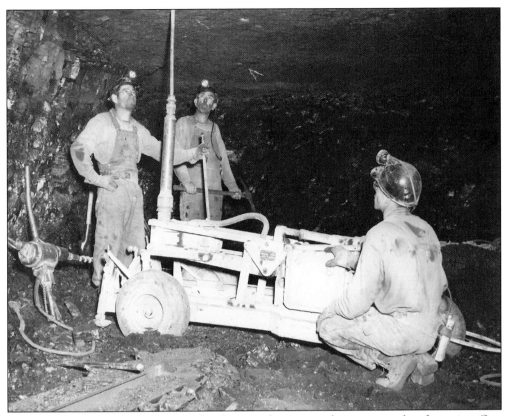

One of the most dangerous aspects of underground mining is the prospect of roof cave-ins. One method of holding the roof was the insertion of roof bolts that would penetrate several layers of rock, allowing the bolt and plate to stabilize the roof. The miners are Willie Lopez (left), Melvin Kilgore (center), and John Toth. They are the operators of a specialized bolting machine.

Another method, and the earliest type, for holding the roof was the use of timbers that would be placed along the rib (sides) of the mine. Timbers were then placed across the top, supported by the rib timbers. Among the installers are, from left to right, unidentified, John Moon, and Ed Overy. After mining was completed, the dangerous process of retrieving the timber was begun.

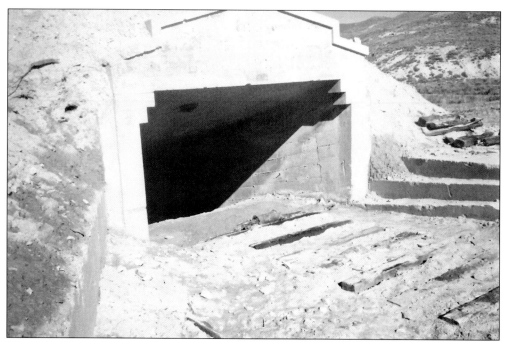

The D.O. Clark Mine portal was constructed in 1937. The mine, the biggest producer in the company's system, was in operation until it was closed in 1963. With the closing, the portal was sealed and then covered over. In 2010, the AML did extensive reclamation work around the old workings, and the portal was uncovered, becoming an archeological artifact.

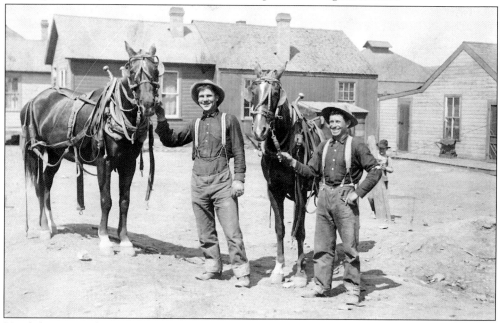

Until the process became highly mechanized, horses and mules were used extensively to move coal and equipment throughout the mines. Stable bosses were responsible for keeping the animals fit and healthy. In 1925, responsible parties are unidentified and Serafino Albertini (right). These men took pride in their job and in the condition of their charges.

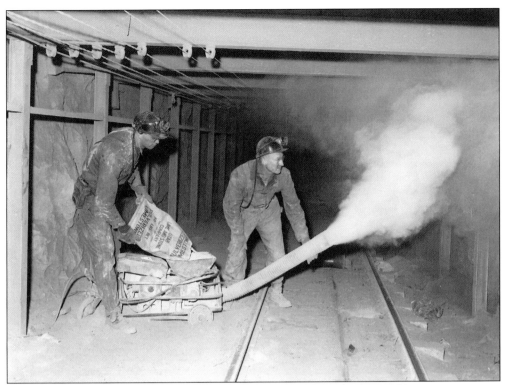

Sandy Dixon (left) and John Stoffa are rock dusting. The dust of pulverized limestone prevents coal dust from igniting and causing an explosion, which has occurred in the past with devastating results. The constant dusting in Superior mines was a factor in an excellent safety record. (Courtesy of the Superior Museum.)

The perfectly cut underground tunnels were the hallmark of the new D.O. Clark Mine in 1939. The mine, designed to be the largest producer of coal west of the Mississippi River, cut across four coal seams, or veins of coal underground, and coal was sent to the surface on a long belt. The company assured investors that the mine would produce into the 21st century. It closed in 1963.

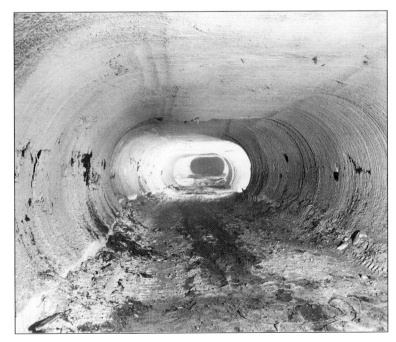

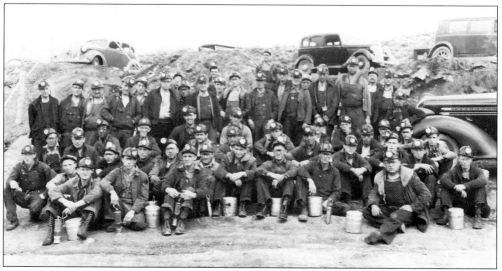

In 1937, the Superior D Mine won the national Sentinel of Safety trophy for having the most hours worked without a lost time accident. The miners about to enter the mine for the night shift are gathered to hear the announcement of the award and to be congratulated on their safety record.

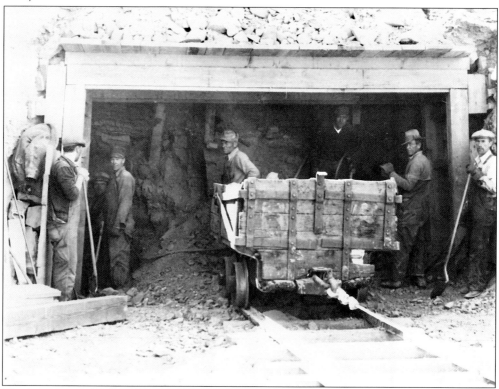

The beginning of the D.O. Clark man way was not a glamorous place with huge machines. The work was done the old-fashioned way, which means manual labor. It was hard work, to be sure, but the forerunner of the most mechanically sophisticated mine in the country was tunneled by hand. After the beginning, a totally mechanized effort opened the mine.

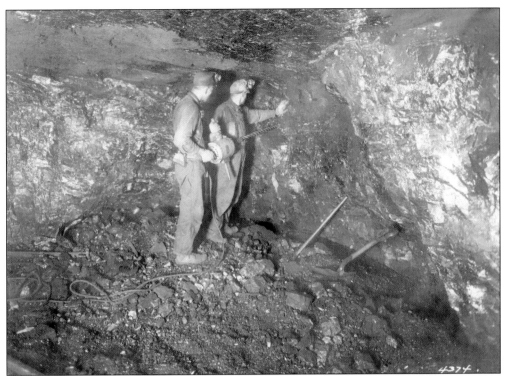

In 1921, shortly after the opening of the Superior-Rock mine, drilling with an electric drill in an area where power was scarce was a vast improvement over hand drilling. This drilling image shows the richness and thickness of a vein of coal in the Superior field. (Courtesy of the J.E. Stimson Collection, Wyoming State Archives, Department of State Parks and Cultural Resources.)

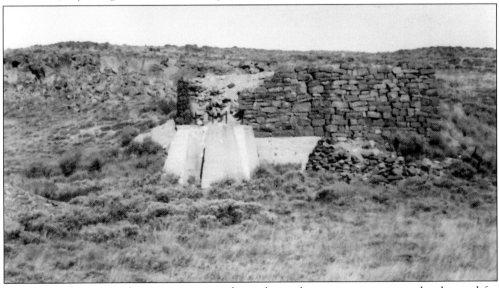

A short, undocumented mining venture of potash was begun in response to the demand for explosives in World War I. It was said to have moved the mineral with ropes and buckets to the railroad for shipment. All that is left are the remains of a potash operation on the ridge above Superior.

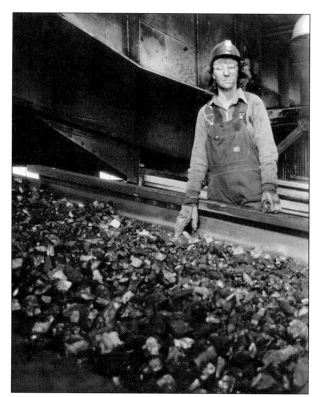

As World War II progressed and manpower became scarce, women were hired for the first time throughout the Union Pacific's system to work around the mines. In 1943, Jane Hanni is picking "boney," or impurities in the coal. The waste is taken out, and the coal proceeds through the tipple to the waiting railcars for shipment.

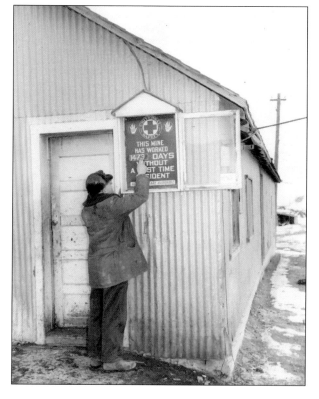

Frank Peternell, the safety engineer for the company, is adjusting the scoreboard showing the number of man-hours worked without a lost time accident. The board shows that the mine has worked 1,479 days without an accident. The Union Pacific stressed safety constantly, and its record was outstanding, winning several national awards for safety.

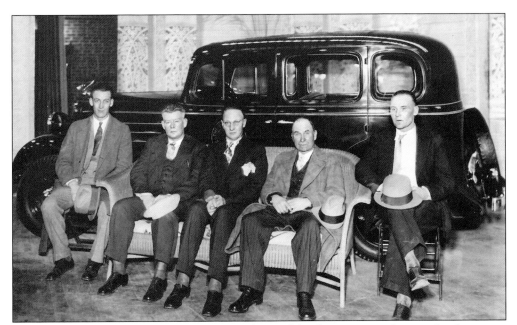

Prizes for promoting safety and holding a good record for the miners working under them were awarded in 1935 to several Superior foremen. They are, from left to right, James Hunter, Richard Arkle, Clyde Rock, Port Ward, and John Ojala. They were recipients of incentive awards. These incentives contributed to the company's safety record. Although there were injuries and fatalities, they diminished as safety was stressed.

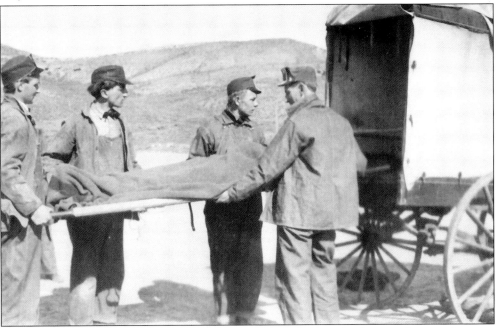

Early in mining history, safety practices were important. In this early photograph near a Superior mine, men are shown practicing placing a stretcher with an injured miner into an ambulance wagon. Although a doctor was available, hospital facilities were distant, and in a dangerous occupation, immediate attention was important.

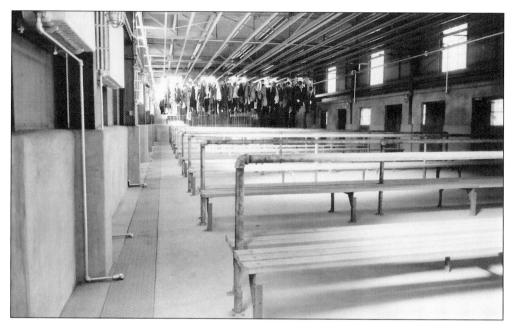

The miners union in early efforts to improve working conditions pressed the company to provide hot showers so coal dust and residue could be washed off before the miners went home. By 1940, the D.O. Clark Mine provided state-of-the-art facilities for its employees. The proud company published the accompanying information in its employee magazine: "The change room provides space for basket-type clothes hangers for 600 employees, together with bench seats and toilet facilities."

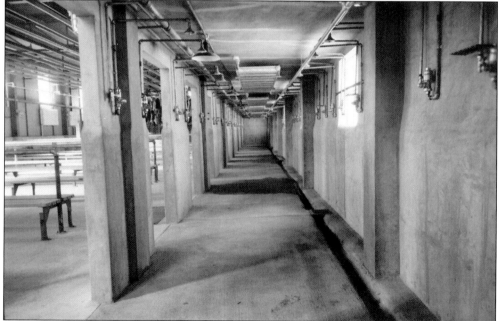

The spray room adjoins the change room, according to the employee's magazine, and is fitted with 72 gang-type showers, delivering automatically circulated and temperature-controlled water through spray heads. According to the company magazine, "Each shower is fitted with a push button–type valve, adjustable for pressure and automatic shutoff after delivery of water."

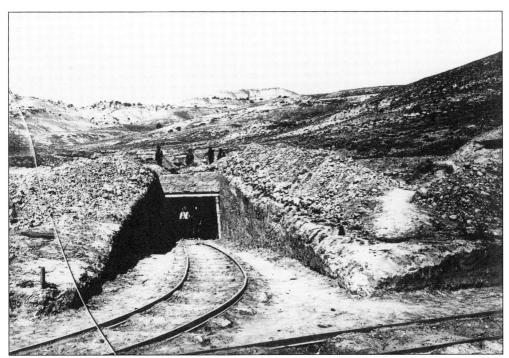

Union Pacific Coal Company's A Mine in Superior was opened on April 30, 1906, and closed in 1923. At A Mine, because coal was close to the surface, it was hauled mostly by mules, although some electric engines were used. A housing camp was built, including a section where the Japanese workers were segregated because of widespread anti-Asian sentiments.

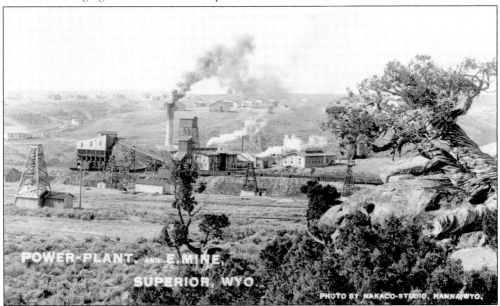

Earlier, E Mine was shown under construction. Here, it is in full operation with the power plant in full swing, making power for the mines and homes. The newly built Superior Elementary School is visible on the hill in the background. The mine was short-lived, and production of coal shifted to other locations. (Courtesy of Leno Menghini.)

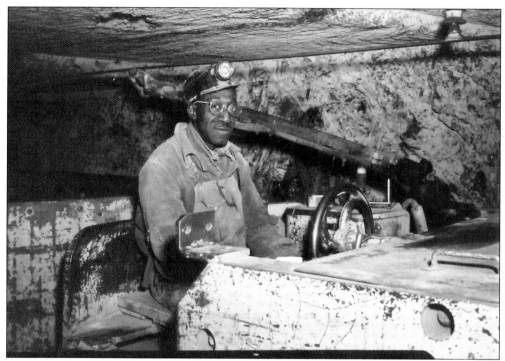

Roy Epps, a longtime employee of the Union Pacific Coal Company, was a motorman, running his electric motor to retrieve coal, to haul supplies, or to haul miners to and from their workplace. Roy was known for his speed and his ability to move men and production quickly.

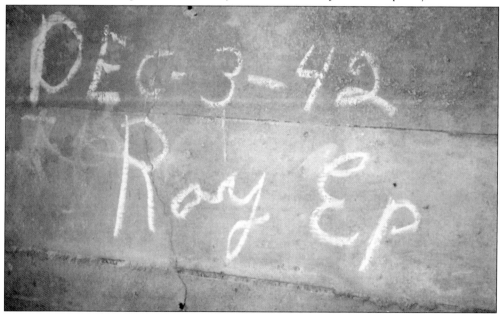

When the D.O. Clark Mine portal was uncovered by the AML in 2010, found on the concrete wall, about 20 feet into the mine, were a signature and date left by Roy Epps. Several names and dates were found in the area, all written in chalk and now exposed to the elements. (Courtesy of the Superior Museum.)

Two

LOOKING AROUND

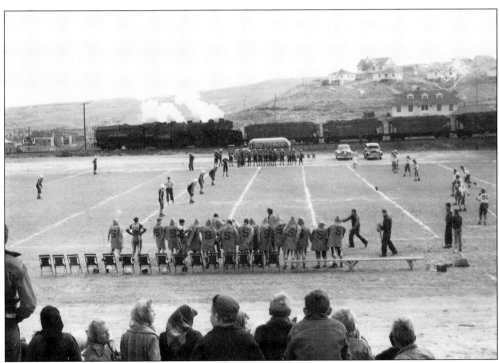

The Superior High School Dragons football team is shown playing a conference rival. A frequent spectator at the games was the engineer of the steam engine hauling coal out of the canyon and bound for the railroad's main line. This image highlights not only a school activity but also Superior, which can be seen beyond the railroad. South Superior is at the left.

The company store played an important role in early mining communities. A full range of products was available, and credit was extended to miner employees. The ballad *Sixteen Tons*, made popular by Tennessee Ernie Ford, is a reflection of real life. The wording above the portico in this image shows that the business belonged to the Superior Coal Company in 1908. The company was merged with the Union Pacific Coal Company in 1916, and the store then became the UP Store.

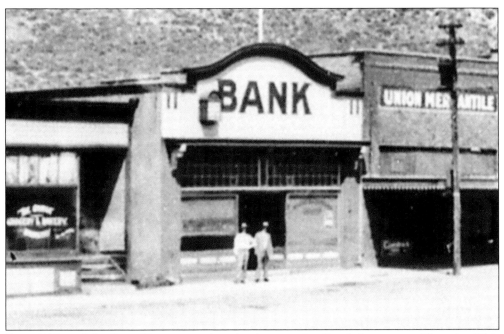

From 1910 until the Great Depression, three banks existed in South Superior and Superior. This 1927 image includes the Miners State Bank on South Superior's Front Street. Other banks were the First National Bank and the First Security Bank. During the Depression, banking activity shifted to Rock Springs and remained there. (Courtesy of the New Studio.)

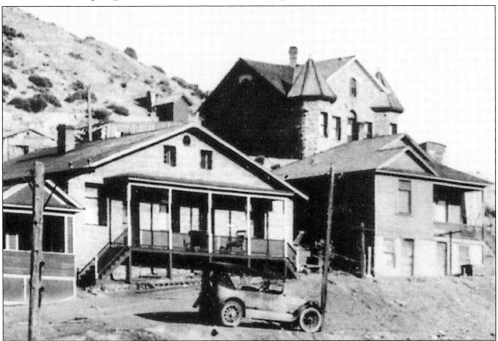

Early privately owned housing in South Superior shows extensive use of sandstone. This image is from 1927, but the buildings date to 1916. The castle-like house at the top has a splendid view of the canyon and community, while the homes below face Front Street. (Courtesy of the New Studio.)

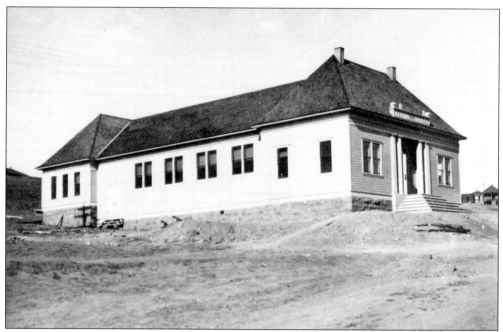

The Superior Opera House was built in 1909 and was destroyed by fire in 1962. The large structure was a multiuse facility. Not only could the stage be used for music and drama, but the building was utilized for community meetings and by the coal company for its gatherings. Wedding receptions and anniversaries were celebrated here. Late in its life, it became a roller-skating rink.

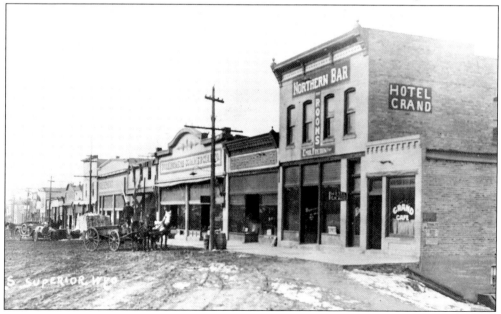

Front Street was named because it faced the railroad tracks. This is as it appeared around 1917. Early in the life of the towns, businesses were flourishing. Among the reasons for this success were the distance to another established community and the difficulties encountered when travelling long stretches. Travel and distance contributed to speculation on buildings and equipment. (Courtesy of the Wyoming State Archives, Department of State Parks and Cultural Resources.)

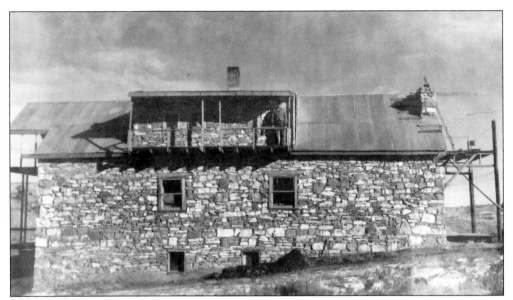

The Acropolis Candy Store built by Gus Thomas, shown here on the balcony, was located on C Hill in Superior. Begun in 1929, Gus quarried the sandstone and carried it stone by stone to be placed in the structure. Blue-and-white trim on the balconies and frames reflect the Greek national colors. The stonework was extraordinary.

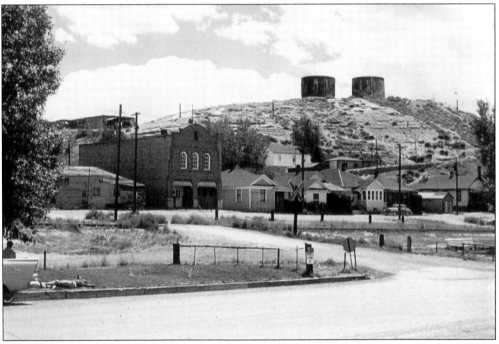

A South Superior scene showcases the town hall and fire station. This structure faced Front Street across the railroad tracks. Above the town hall are the remains of the South Superior Elementary School, replaced by a new building in 1952, and two water tanks, which delivered potable water to the community.

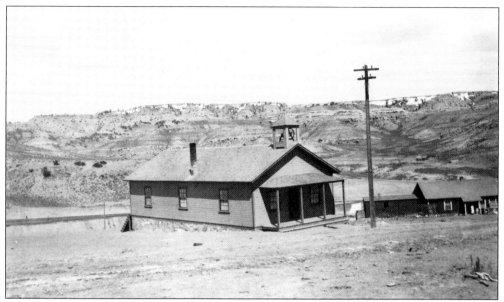

The Community Church in Superior is pictured about 1915. The building was provided by the coal company and several denominations—including Congregational, Mormon, Lutheran, Episcopal, and others—shared the structure. Later, some denominations built or purchased their own facilities or met in other locations. The building served until 1963. (Courtesy of the W.B.C. Gray Collection, American Heritage Center, University of Wyoming.)

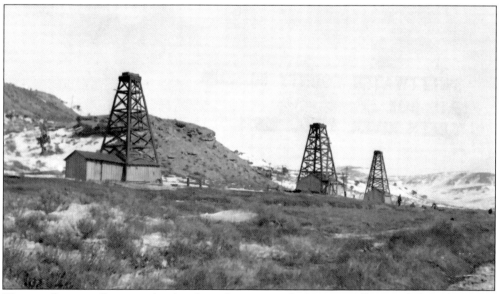

Water wells in a valley several miles above Superior in the Leucite Hills provided good water to the communities. Located in a dry climate, the wells brought water to the surface, then pumps pushed the water to the top of the canyon's ridge, and gravity took it into the towns. These wells were drilled in response to growth during World War II.

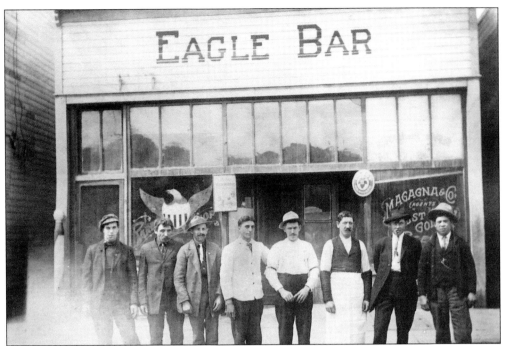

The Eagle Bar, one of Front Street's favorite watering holes, is pictured before Prohibition took effect in 1920. Of the gentlemen pictured, only Felix Menghini, in the long white apron, is identified. After Prohibition began, the Eagle Pool Hall apparently continued in business, as did the other "pool halls" on Front Street. (Courtesy of Ray Lorenzon and Bob Lavery.)

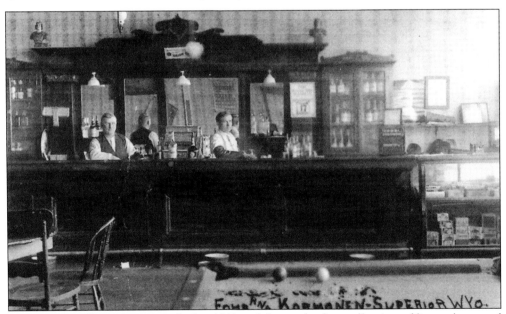

The upscale Alberta Bar opened after 1910 and featured a fine collection of liquor, beer, and wine. Pekka Korhonen (left) and ? Fohr had previously owned and operated the Sunrise Hotel, but it apparently burned down. Pool was popular, and a major accoutrement, a spittoon, is present. (Courtesy of Wayne Korhonen.)

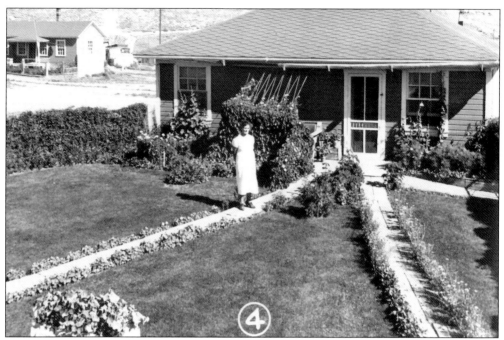

Each year, the Union Pacific Coal Company sponsored contests and gave prizes for beautiful yards and gardens. At 7,000 feet in elevation and in a very dry climate, growing a garden was not an easy task. Nevertheless, in 1937, Salmi Walkama took first place for her lawn and flowers.

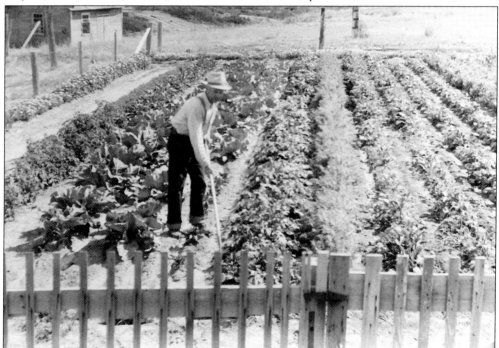

Robert Applegate is working in his 1935 winning vegetable garden. The area's elevation means a short growing season, and the desert terrain requires daily watering. Applegate was able to grow ample vegetables to share and to can. This was one of many vegetable gardens in the canyon.

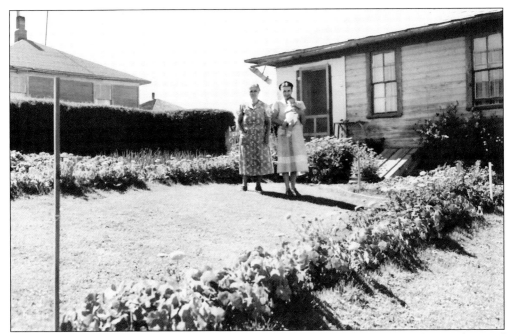

The 1950 first prize for an exemplary yard went to Orsala Angeli (left), who is admiring her yard with her sister-in-law Angela Angeli holding her daughter Wanda. The desert bloomed into a rose under caring hands, usually those of a resident from a foreign land where gardening was a way of life and greenery was cherished.

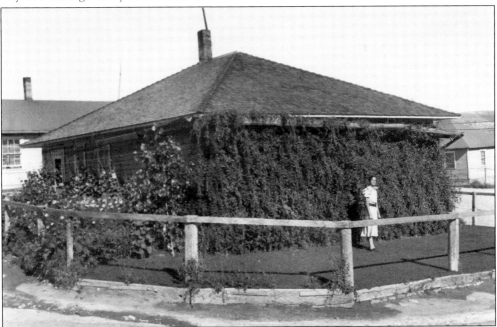

In 1933, the Koech residence was surrounded by greenery due to the diligence of Rosie Koech. These residents emigrated from Europe and brought their talents for gardening with them. The very rocky soil of Horse Thief Canyon provided a challenge for even the most skillful green thumbs. Those successful gardens deserved a prize.

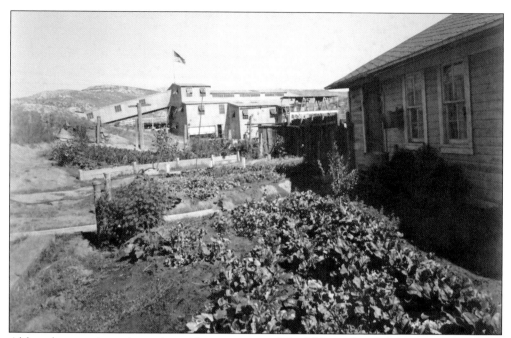

Although not a winner in any beautification contest, John Milonas found that growing vegetables was perfectly compatible with mining and shipping coal from the D.O. Clark Mine tipple next door. The garden matched the mine in producing useful products. From garden to mine, the miner worked at both.

Greenery was not limited to Superior, as the town of South Superior established the Front Street Park in 1939, with trees brought into town from Eden Valley, an irrigated farm area to the north. The park has provided space for activities throughout the years.

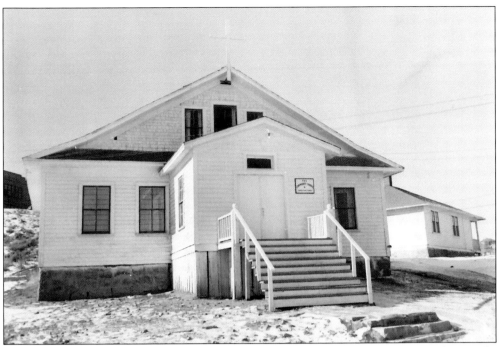

In 1954, Congregational Church members purchased the former Superior Medical Clinic and a nearby home as a church and parsonage. The congregation had room for services, Sunday school, other classes, and social events. For nearly 50 years, the Congregational Church had shared space in the Union Community Church. (Courtesy of Margaret Arkle Bettolo.)

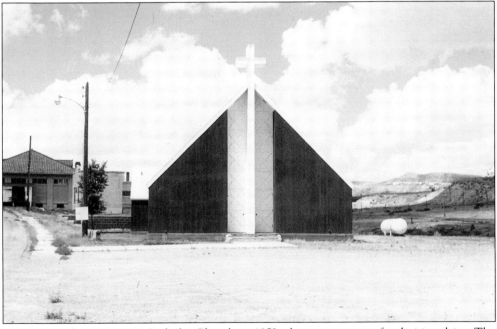

Members built St. Vivian's Catholic Church in 1952 after an extensive fundraising drive. The church, located in Superior, featured a simple redwood interior, with room for services and classes. The building is still used today and is a branch of the Rock Springs Catholic community.

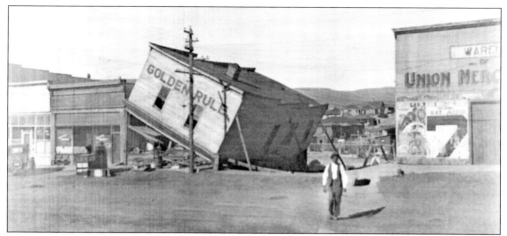

On August 19, 1926, the former Golden Rule Store in South Superior was completely demolished by an explosion. Some people were of the opinion that dynamite was being used, but the sheriff refuted that claim. A moonshine still and two barrels of mash were found, leading to the arrest of renter Dan Razzis, who was incarcerated. The building housed a soft drink shop. (Courtesy of Ted Vallis.)

Making moonshine was a common practice in Horse Thief Canyon, and Prohibition did not end the use of alcohol. The Volstead Act of 1920 defined what constituted liquor, but it was largely ignored. Many Europeans brought distilling skills with them to America. Every fall, railroad boxcars came into town loaded with California Zinfandel grapes. Some residents were especially active in making wine and even used the residue of grapes to make grappa. (Courtesy of the Rock Springs Historical Museum.)

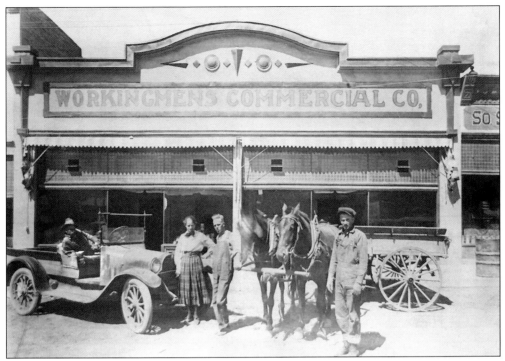

Finns were heavily represented in the mining communities of the West. The Workingmen's Commercial Company was a Finnish cooperative with stores in Hanna, Rock Springs, and South Superior. In 1927, two kinds of transportation evidently delivered goods from the store to patrons. The Finnish store was one of two department stores on Front Street. It was founded in 1910. In front of the store are, from left to right, unidentified, Mary Asiala, Haven Musgrove, and unidentified.

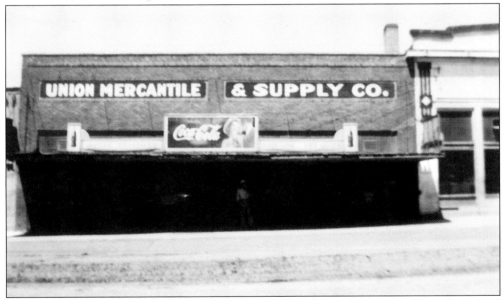

The Union Mercantile and Supply Company was the other department store on Front Street, and although it catered to all groups, its heritage was Tyrolean. The Merc sold meats and groceries, as well as dry goods, hardware, sporting goods, and furniture. It was established in 1909.

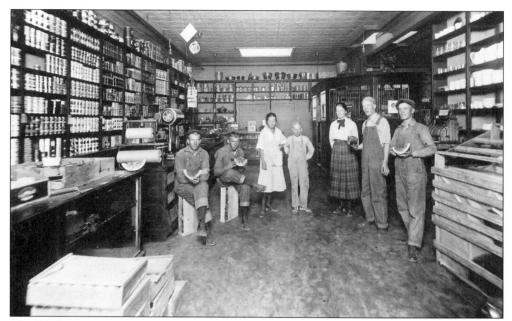

The Workingmen's Commercial Company was a Finnish cooperative that carried high-quality goods and products. The dry goods were reputed to be exceptional. Mary Asiala (third from right), Haven Musgrove (second from right), and Wayne "Skinner" Korhonen (fourth from right), were longtime employees; others are unidentified. The store came to its permanent site in 1910, with the image made in 1927.

A wonderful new washing machine is being displayed in the Workingmen's Commercial Company in 1927. Customers and employees pose with the machine. Outside, an interesting contraption was used to fill automobiles with gas. The customer would pump the desired gallons to a head-high tank and then release the gas by gravity into the vehicle.

The true center of the town of Superior included, from left to right, the clubhouse, the Superior High School and gym, the Union Pacific Coal Company Store, and St. Vivian's Catholic Church. Just out of sight to the left is the opera house. The clubhouse (used for social functions) was built in 1928, the high school in 1925, the company store in 1908, and St. Vivian's in 1952.

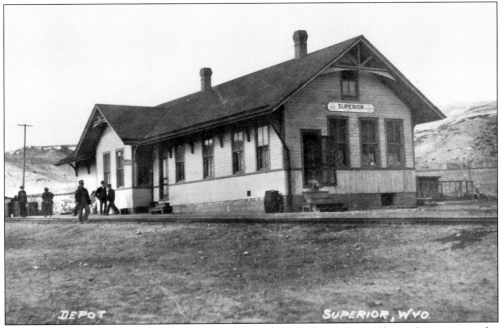

According to the book *Sweetwater County*, plans for a rail spur from Thayer Junction on the Union Pacific Railroad's main line to the newly established mining community of Superior took form as early as 1903. By having its own depot, Superior was able to consign coal shipments to the main line quickly and accurately. The building is believed to date from 1906.

During World War II, housing for hundreds of new miners became critical. One answer to the housing shortage was to place two railroad boxcars a few feet apart, build a room between them, and roof the structure, creating a duplex. Earlier boxcars with the wheels cut off were used as housing. This image pictured such a development in Superior's D Camp.

Another way to provide housing in a hurry was to call on the federal government to create housing for workers involved in a critical wartime industry. The government responded by building hundreds of "government apartments" in Superior. This also meant a rapid development of water and sewer facilities to meet government specifications.

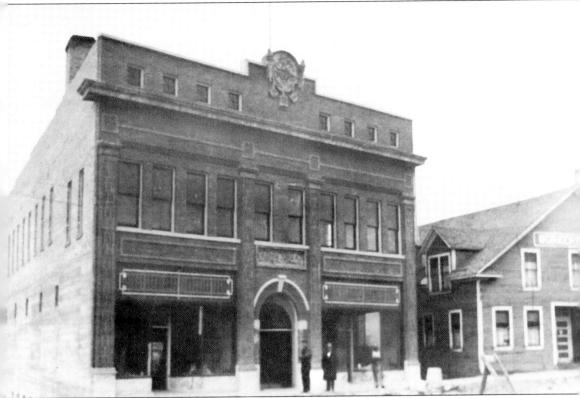

Perhaps the most important privately held building in South Superior was the Union Hall. The hall is on the National Register of Historic Places because it was the largest such structure in the West. Built in 1921, it was owned and operated by six local unions of the powerful United Mine Workers of America, hence the symbol atop the building's facade. It housed an auditorium, hosted meetings, and held dances and political rallies. At various times, downstairs was known to have a store, a bowling alley, and a medical clinic. When mining ended and the unions went out of business, the building began to deteriorate, but AML funds saved it, transforming it to an interpretive center. (Courtesy of the Wyoming State Archives, Department of State Parks and Cultural Resources.)

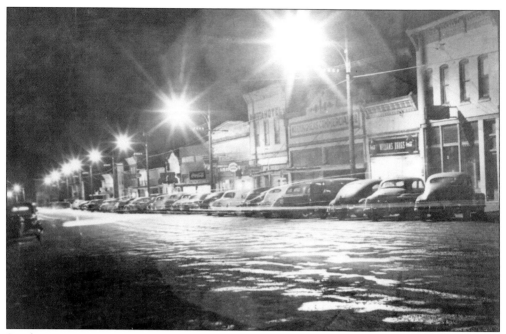

South Superior's Front Street in the late 1940s was a busy place at night. With eight bars, several stores and shops, hotels, and confectioneries, there was much activity. Newly installed mercury-vapor lights create a bright glow on the street and surrounding hills on a snowy night. (Courtesy of the Superior Museum.)

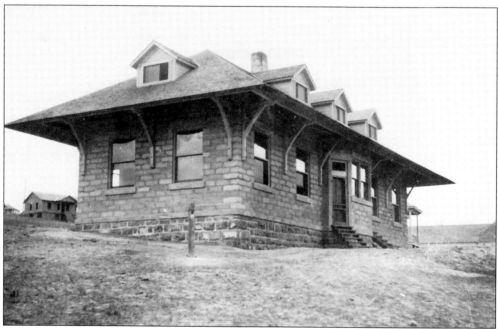

The original nerve center of mining activity in Horse Thief Canyon was the Superior Coal Company's mine office, constructed between 1906 and 1908 on Superior's main thoroughfare near the company's other major structures, such as the store. The building gave way to a more modern structure in 1937.

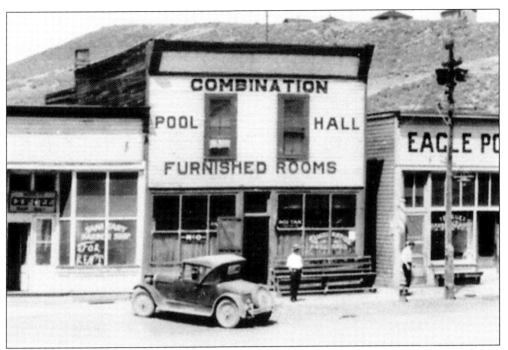

From 1920 until 1933, Prohibition on the sale of liquor was part of the US Constitution. Prohibition was rarely enforced in the county and apparently, too, in South Superior. The Combination was no longer a bar but instead a pool hall. After 1933, it became a bar again. It has been said that nothing changed. Liquor was available before, during, and after Prohibition, and according to legend, so were painted ladies. (Courtesy of the New Studio.)

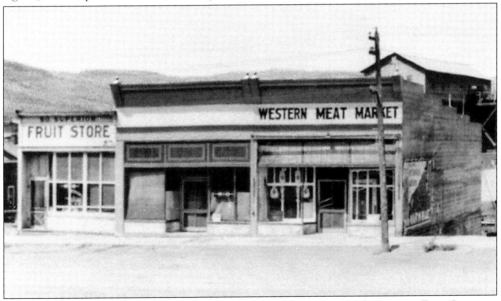

Three thriving businesses established on Front Street were the South Superior Fruit Store, an empty-looking building where liquor was supposedly available, and the Western Meat Market. Looming behind is the B Mine tipple. Although some distance away, it was a reminder of the town's economic base in 1927. (Courtesy of the New Studio.)

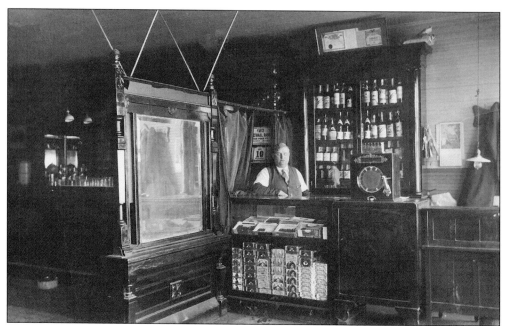

Pekka Korhonen, a Finnish immigrant, was a cofounder of the Alberta Bar between 1910 and 1920. The business thrived before Prohibition—and probably during it, too. Available on-site were a hotel and restaurant for a complete and convenient stop for visitors and townspeople alike. (Courtesy of Ray Lorenzon.)

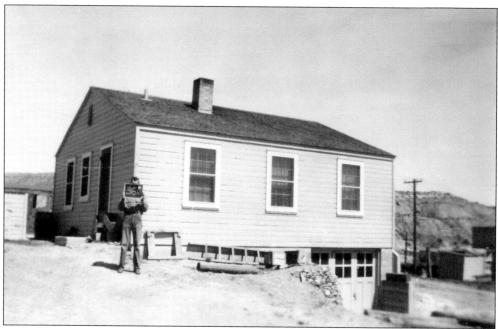

With a rise in coal production during World War II, the need for upgraded company housing increased. Homes were constructed between 1941 and 1944. When a decline in population came, most of these buildings were sold and moved to locations in other communities. The homes were modern, well built, and inexpensive—a mover's bargain.

Shown with their 1931 roadster and the unaltered Crystal Theater in the background, are, from left to right, Joe Lorenzon, Pete Lorenzon, and unidentified. At this time, it was normal for men to peruse White City wearing ties and bow ties. (Courtesy of Ray Lorenzon.)

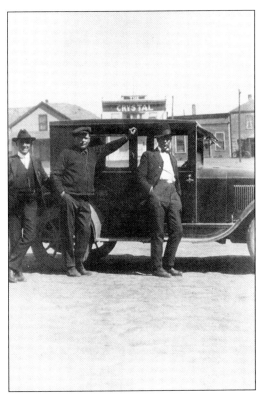

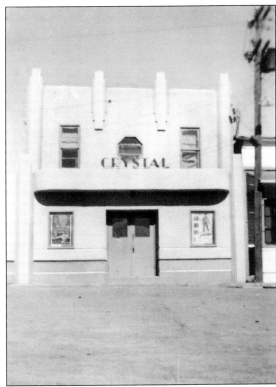

The Crystal Theater showed movies and was lauded by an employee magazine for having the finest sound system in the state. It was also a site for live performances, which were much enjoyed by adults. The Crystal was built in 1912 and underwent extensive remodeling for this 1946 image.

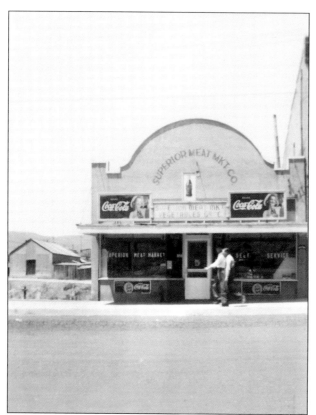

The Superior Meat Market on Front Street specialized in a variety of meats, including the processing of game such as deer, elk, and antelope. The market featured a frozen-food locker plant, where spaces could be rented by individual families to store their frozen food. It was an interesting business, selling meat and then renting locker space to store it.

The house of the superintendent of mines, constructed in 1909, was an imposing structure built high on B Hill. As more modern housing was constructed and the superintendent moved, the building became the teacherage, a residence for single female teachers. The teachers lived and cooked meals there, and it was the site of many courtship opportunities for local men.

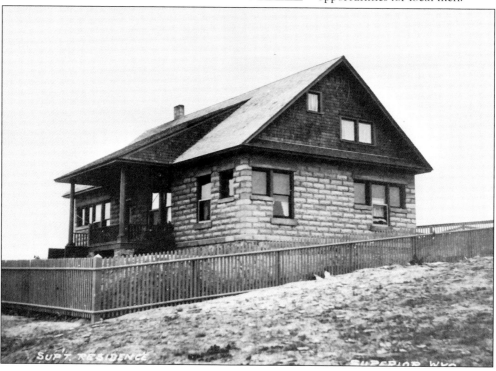

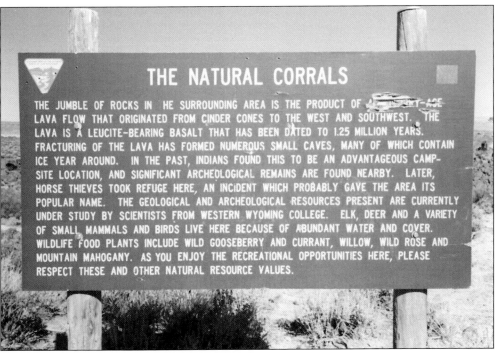

THE NATURAL CORRALS

THE JUMBLE OF ROCKS IN HE SURROUNDING AREA IS THE PRODUCT OF A RECENT-AGE LAVA FLOW THAT ORIGINATED FROM CINDER CONES TO THE WEST AND SOUTHWEST. THE LAVA IS A LEUCITE-BEARING BASALT THAT HAS BEEN DATED TO 1.25 MILLION YEARS. FRACTURING OF THE LAVA HAS FORMED NUMEROUS SMALL CAVES, MANY OF WHICH CONTAIN ICE YEAR AROUND. IN THE PAST, INDIANS FOUND THIS TO BE AN ADVANTAGEOUS CAMP-SITE LOCATION, AND SIGNIFICANT ARCHEOLOGICAL REMAINS ARE FOUND NEARBY. LATER, HORSE THIEVES TOOK REFUGE HERE, AN INCIDENT WHICH PROBABLY GAVE THE AREA ITS POPULAR NAME. THE GEOLOGICAL AND ARCHEOLOGICAL RESOURCES PRESENT ARE CURRENTLY UNDER STUDY BY SCIENTISTS FROM WESTERN WYOMING COLLEGE. ELK, DEER AND A VARIETY OF SMALL MAMMALS AND BIRDS LIVE HERE BECAUSE OF ABUNDANT WATER AND COVER. WILDLIFE FOOD PLANTS INCLUDE WILD GOOSEBERRY AND CURRANT, WILLOW, WILD ROSE AND MOUNTAIN MAHOGANY. AS YOU ENJOY THE RECREATIONAL OPPORTUNITIES HERE, PLEASE RESPECT THESE AND OTHER NATURAL RESOURCE VALUES.

Self-explanatory signage tells about the Natural Corrals, a site placed on the National Register of Historic Places because of its unique geological formations. Legend has it that stolen horses were kept in the area, where the animals could remain with abundant food and water. (Courtesy of Cyndi McCullers.)

The Natural Corrals and the ice caves were, and are, favorite recreation areas. They are blessed with abundant water from springs, greenery, and shade. The opportunity to explore caves, to climb, and to find a native artifact is real. The area is as much a draw today as it was in 1906 when the towns were founded. (Courtesy of Cyndi McCullers.)

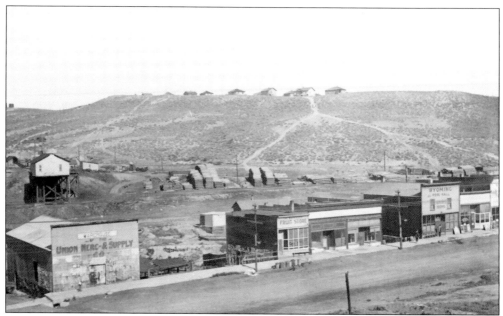

Here is Front Street as it looked before 1915. Several businesses were established and were in operation shortly after the first mines opened in 1906. Behind the buildings are the tipple and maintenance yard of the UP's B Mine in Superior, and in the background high on the hill are houses in Superior. Proximity made them twin towns.

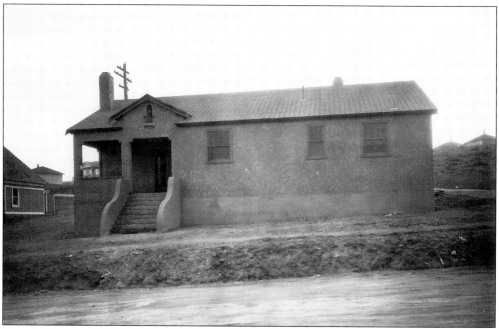

The clubhouse was located across the street from the UP Company Store. It was extensively used for small meetings and social events, such as bridal showers and receptions. In the interior were an elegant main room plus a complete kitchen and storage facilities. The building was constructed in 1928, but this image was taken in 1931. It was moved and is now a restaurant and bar in Rock Springs.

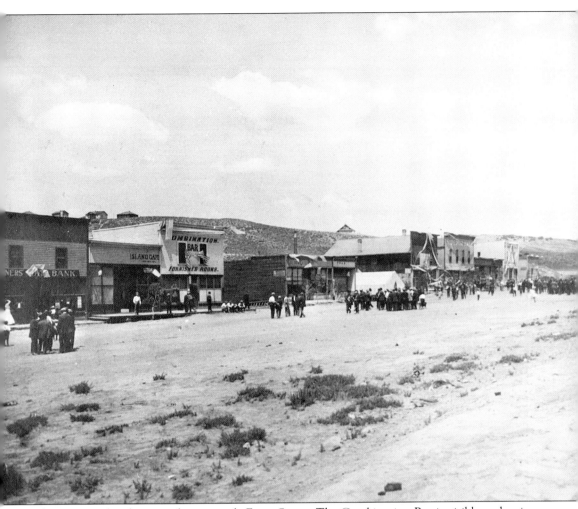

This is an undated image of a very early Front Street. The Combination Bar is visible and so is the Miners State Bank. The *Wyoming Semi-Weekly Tribune* of Cheyenne on April 21, 1911, said that the bank had opened a temporary building but would move to a modern facility next to the Union Mercantile. This image shows the temporary location. Only one woman appears and is wearing a long dress, as seen in the left center of the image. The sidewalk seems to be constructed of wooden planks. Flags, banners, and bunting surely indicate a July Fourth celebration. (Courtesy of Ray Lorenzon.)

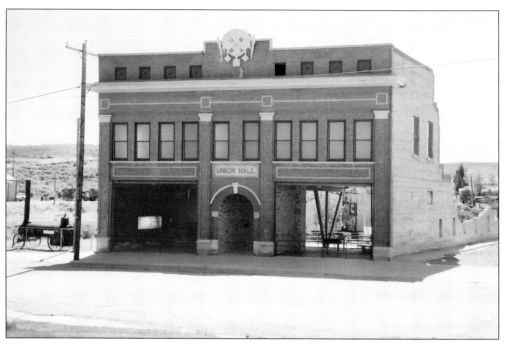

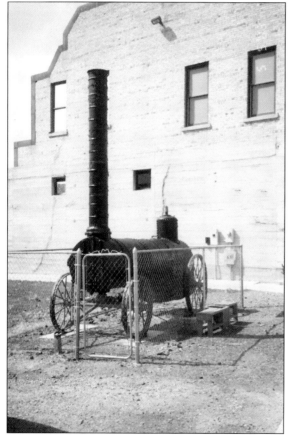

The restored Union Hall is now a visitors and interpretive center. The classic facade of the building is reinforced, and the roof and most unstable walls have been removed. Inside are a pocket park and several interpretive plaques and images. The restoration was funded by Abandoned Mine Land funds, which are generated by a tax on present-day coal production nationally.

This steam engine, known as a Nagle Machine, made a first appearance in about 1862. This model on display near the Union Hall was built between 1894 and 1897 and is on loan to the town by the family of Mary Knezovich. Note the restoration on the building next door. It is part of the AML stabilization.

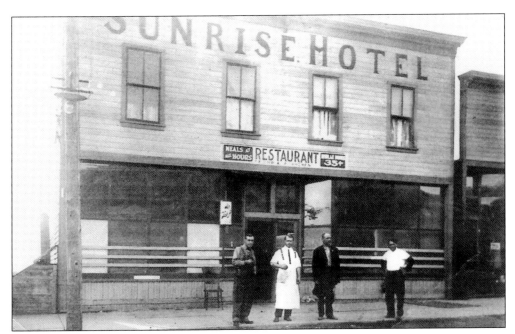

Almost no one has heard of the Sunrise Hotel. It was built very early in South Superior's history. Proprietors were Korhonen and Fohr, as seen on the sign. These two are the same duo that later owned and operated the Alberta Bar. Descendents of the two say this hotel burned to the ground, so the partners opened the Alberta. (Courtesy of Wayne Korhonen.)

It looks like a twin to the Sunrise Hotel, but this image cannot be the same building, as the former allegedly burned to the ground. The sign would also indicate this was a restaurant or confectionery with apartments located upstairs.

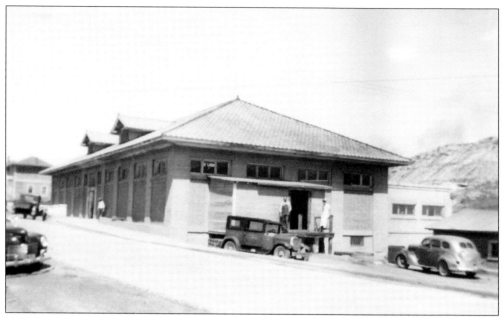

The Union Pacific Coal Company Store was built by the Superior Coal Company in 1908 and is shown elsewhere in this book. This later image shows an altered, more efficient building. The largest store in the canyon, it offered a complete array of products, including groceries, dry goods, hardware, furniture, clothing, household goods, and appliances. A complete gas station and repair and tire shop were adjacent to and part of the store.

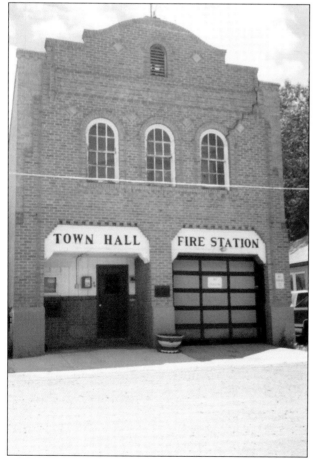

South Superior Town Hall is no longer in use as the site of town government, the jail, or the fire station. The second floor was used by lodges and clubs as a meeting place and also for social events, such as dances and holiday parties. No date of construction is available; however, images taken in 1927 show a different building at the site. But in a 1935 image, it exists. This photograph was taken in 1991. (Courtesy of Flora Tosolin.)

Superior High School was built in 1925 by the Kellogg Lumber Company for the sum of $75,000, a substantial amount at the time. It has been said that the plans were drawn in Omaha by the Union Pacific, and the same plan included a high school at Reliance, Wyoming. The high school was perched on a steep second B Hill and, at times in winter, it was difficult to get vehicles to the top. However, the "higher education" location did not stop students, as the top mode of transportation was walking. From its opening until the last class graduated in 1962, the building housed grades 7 through 12. Students after that date were bused to Rock Springs to attend junior high school and high school. The high school's gym in the background was made available in 1931. The buildings were razed shortly after closure. (Courtesy of Patty Hardy James.)

In 1939, the major executives of the Union Pacific Coal Company gathered at the D.O. Clark Mine, where it is thought a dedication of the facility occurred. Referring to this occasion, the book *History of the Union Pacific Coal Mines* states, "Time marches on, and with a great reserve accessible to the D.O. Clark Mine, which will later be prospected and developed, production should be going well into the twenty-first century, and so Superior, unlike many of the early towns, is not soon destined to assume the title of ghost mining town." The mine closed in 1963, and Superior faded away. The executives are, from left to right, George B. Pryde, Harry G. Livingston, George A. Brown, C.E. Swann, and Eugene McAuliffe.

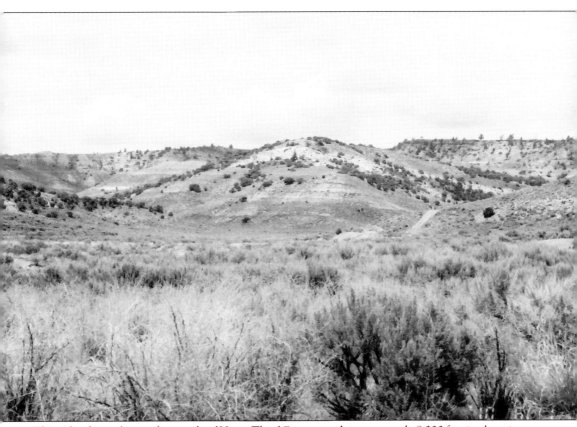

This ridge forms the northeast side of Horse Thief Canyon and rises to nearly 8,000 feet in elevation. The ridge, formed of massive sandstone escarpments, is home to juniper and pine trees. Where springs occur, they water willow and aspen. The ridge was a favorite outdoor recreation area for hiking, climbing, and picnicking. Hunting deer in season was extensive. Beyond the ridge are the Leucite Hills, with the Natural Corrals and ice caves among the geologic features.

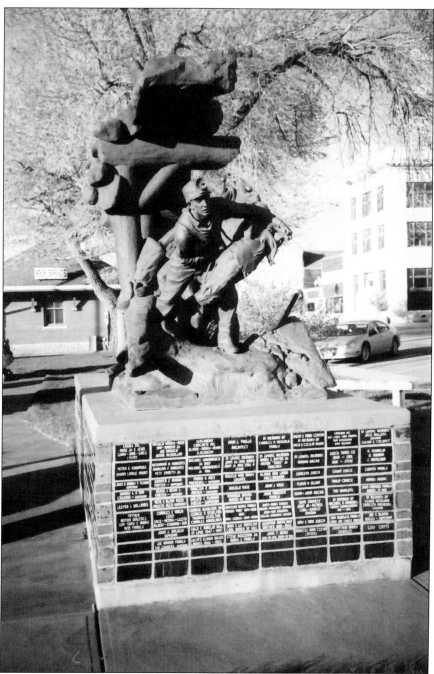

A monument dedicated to the miners of Sweetwater County was raised in 1993 at Depot Park in Rock Springs to commemorate the 100th anniversary of Wyoming's statehood. Many Superiorites participated in fundraising activities and purchased bricks with names that honor miners and family members. Although not located in Superior, it commemorates its residents and laborers equally with others in the county. The sculpture *Clearing the Haul Way* is dedicated to the county's miners and their legacy. It depicts an early-day miner and a horse engaged in very heavy manual labor. The sculptor was Edward J. Fraughton.

Three

THEY CAME FROM AFAR

Superior Junior High School students perform an International Day program, celebrating the various ethnic and national groups living in the community. In 1940, it was reported that over 30 nationalities were living in the communities. It has been written that one motive for the company to hire miners speaking different languages is that it would make it more difficult for workers to organize. They organized into unions anyway.

KUOPPALAN POIKATAL
SUPERIOR WYO

According to Union Pacific's statistics, the Finns were the largest European group working for the company. Their expertise working with wood and timber made them invaluable when dealing with timber props to support the mine roof. This occupation was the most dangerous in mining, and Finns suffered a disproportionate number of injuries and fatalities. These young Finns lived in a boardinghouse rented from the company.

Henry Tosolin immigrated to the United States from Italy in 1915. As a miner, he came to Horse Thief Canyon in 1921. He later became town marshal, the lone peace officer for the town of South Superior, a position he held until he retired in 1961. Most immigrants were proud to be in the United States and studied to become American citizens. (Courtesy of Patty Hardy James.)

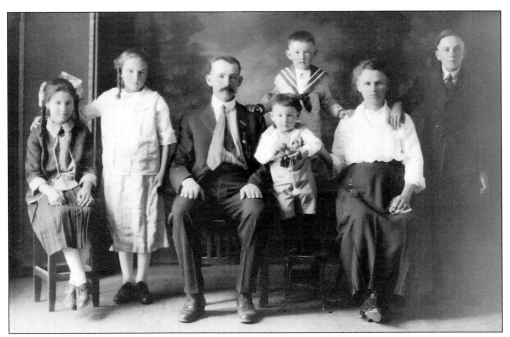

The Tomich family members are, from left to right, Mary, Anna, George, Joe, Mike, Katherine, and John. They represented a portion of the many Slavic residents of Superior. George immigrated to the United States from Croatia in 1903 and came to Superior in 1918. The Slavs brought their culture with them in their food, their religion, and their languages.

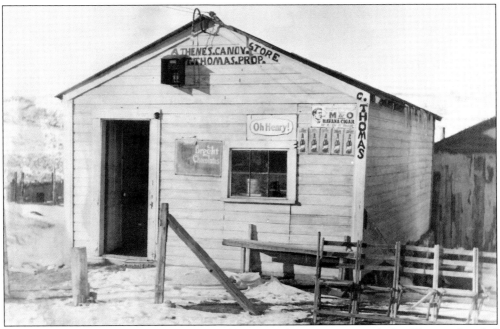

The Greeks were prized as good workers and known to be entrepreneurial. Gus Thomas founded his Acropolis Candy Store on C Hill. In addition to having a small building and business, he was a noted marcher in the annual Labor Day parade, walking in Greek costume as Demosthenes looking for an honest man.

Gus Thomas began working on his expanded Acropolis Candy Store in 1929. He quarried the sandstone and wheeled the blocks to his landmark without benefit of machinery. The building was noted for its blue-and-white balconies and trim. The Acropolis was the only commercial venture on C Hill in Superior and was an oasis for visitors looking for a cold drink or a relaxing game of cards. According to former residents, much neighborhood gossip transpired at the Acropolis. Unfortunately, the interior of the building burned in the 1970s, and it had to be demolished. (Courtesy of Leno Menghini.)

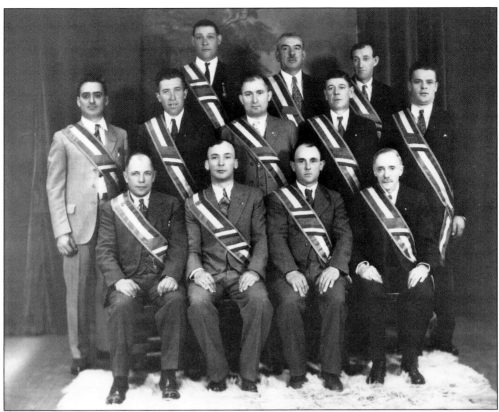

One of the largest groups identified by the company was the Tyroleans. In company statistics, they are identified as former residents of the Austrian Empire who spoke Italian. Fraternal lodges were formed by many groups. This one is the Tyrolean Fratellanza in 1927. The lodges provided services, such as hospitalization, death benefits, widow and children's help, and other assistance. The unidentified Fratellanza officers are pictured. (Courtesy of the New Studio.)

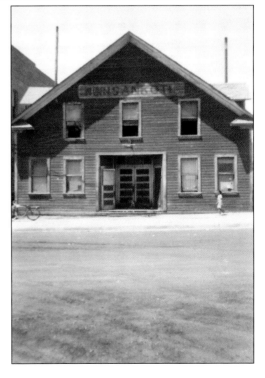

The Finn Hall, which was destroyed by fire in 1952, was the social, political, and cultural center for the Finns in the community. At times, it was known as the Workers Hall, because organizing and political activities were paramount. In both 1910 and 1912, Superior citizens cast one of the largest votes for the Socialist Party in the state. Some of these votes and organization were from Finns.

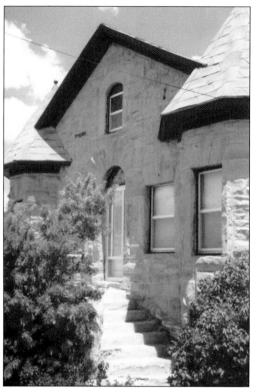

The castle is perched high on a hill overlooking South Superior and the canyon. It was constructed of native sandstone in 1916. The builder was Angelo Pellegrini, a stonemason who had emigrated from Italy. Carved on either side of the date, located above the center window, are the large initials V.E. Conjecture which stand for Victor Emmanuel III, who was king of Italy in 1916. (Courtesy of Patty Hardy James.)

Japanese residents celebrate the Sunada wedding. The Japanese were first housed separately from others, usually in smaller homes than other miners. Behind the dog, the bride and groom are pictured here in a white blouse and dark suit. Many Japanese men were employed in the Sweetwater County mines.

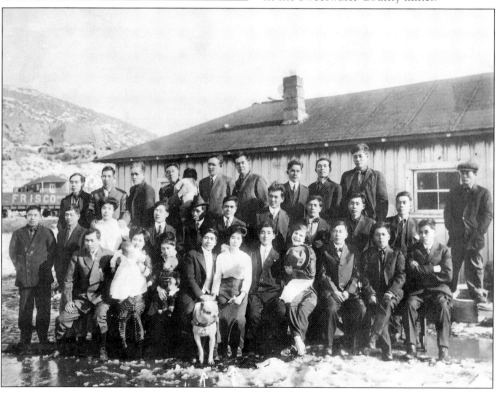

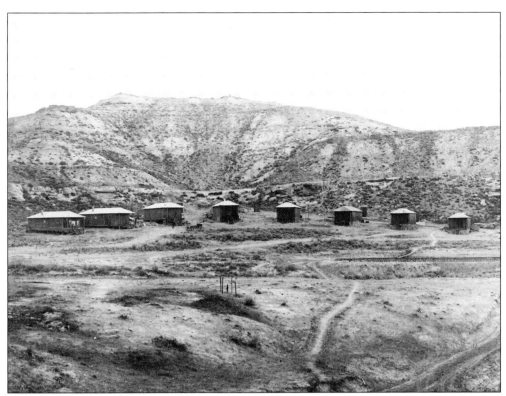

Japanese residents were housed in an isolated area built in 1907 at A Camp. "Jap Town," as it was called, featured small cottages at a distance from others. Because of prejudice at the time, it seems that all Asians were subjected to isolation. Koreans in Superior were also relegated to their own area.

Carl J. "Swede" Carlson came to Superior in 1940 after serving with the Union Pacific in other locations. He had come to the United States from Sweden as a young man in 1918. In Superior, he was named machine boss, which meant he was in charge of all equipment, and at the time of this 1942 image, the Old Timers' Association was honoring him for all his hard work.

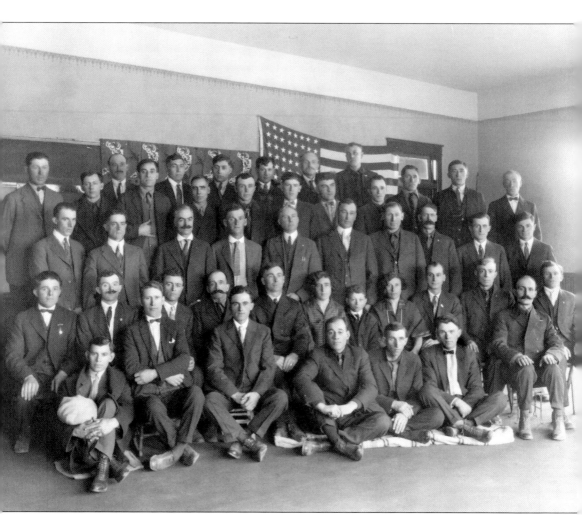

An eagerly sought activity among those who came from foreign lands was the opportunity to learn English and to prepare for citizenship. In 1927, the Americanization class included Greeks, Poles, Slavs, Italians, Austrians, Finns, Swedes, and others. It was taught annually by John Hill at the South Superior Elementary School. These Americanization classes were very popular, and their success is reflected in statistics from the Union Pacific, which show a steady decline in foreign workers and a steady increase in American workers because citizenship was granted to an increasing number of employees. The classes were the equalizer in the American ethnic melting pot. (Courtesy of the New Studio.)

Four

LIFE IN HORSE THIEF CANYON

Superior dancers are performing at the Crystal Theater in 1941. Cultural opportunities for children were abundant prior to World War II. The dancers are, from left to right, Don Tyler, Carma Robinson, Kate Dailey, and Norma Lavery. Instructors included people who lived in Superior and those who came out from Rock Springs on a regular basis. (Courtesy of Norma Lavery Jordan.)

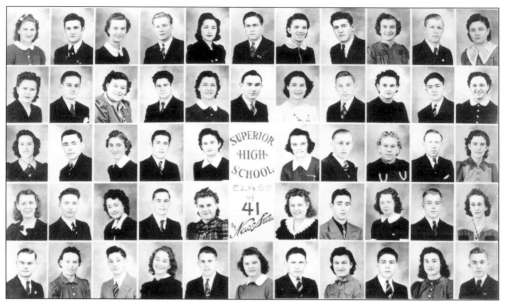

The Superior High School graduating class of 1941 in the composite photograph demonstrates the size of high school classes during the war. Schools were classed by size for competition, and Superior High School was in the same league as Rock Springs, Green River, Rawlins, Evanston, and others. (Courtesy of Ray Lorenzon.)

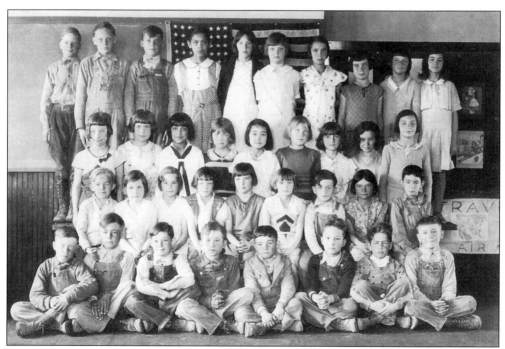

A portion of the same class is shown at South Superior Elementary School. The other part of the class attended Superior Elementary School. Both were part of Sweetwater County School District No. 8. Students from Thayer Junction, Point of Rocks, Salt Wells, and Baxter were bused to Superior. (Courtesy of Ray Lorenzon.)

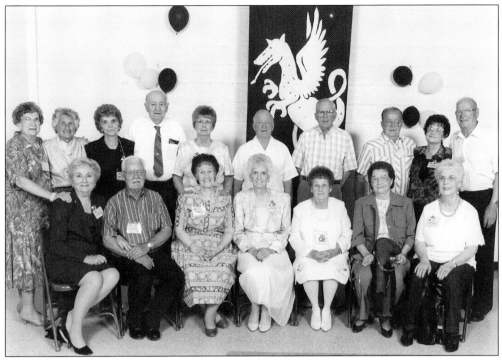

Members of the class of 1941 of Superior High School attended the Superior all-class reunion in 2000. This anniversary, nearly 60 years after graduation, shows Superior's incredible drawing power, considering that the school closed in 1963. (Courtesy of Ray Lorenzon.)

Former Superior superintendent of schools Ivan Willey attended the 1986 all-class reunion with his wife, Evelyn. After leaving Superior, Dr. Willey was named dean of the College of Education at the University of Wyoming, a position he held for several years before retirement. (Courtesy of Flora Tosolin.)

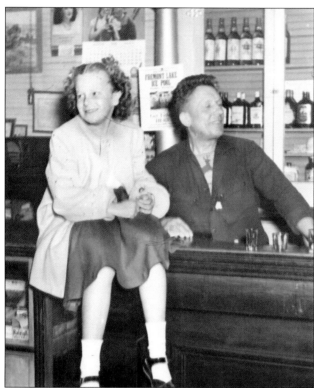

Sherry Tennant, who was eight years old in 1947, shares a moment with Frank Mocellin at his bar on Front Street. She is clutching the $100 bill he gave her earlier because she had picked his name out of a hat, which made him the winner of an automobile being raffled by the United Mine Workers Union. (Courtesy of Sherry Tennant Pecolar.)

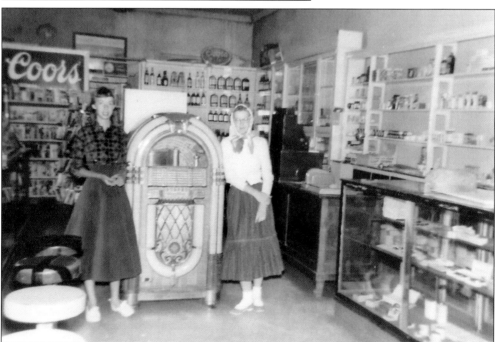

Patty Hardy (left) and Nan Babel are all decked out and enjoying the jukebox at Williams Drug in 1959. The drugstore, a favorite teen hangout, was located on Front Street. The poodle skirts were a teen fashion statement of the time. (Courtesy of Patty Hardy James.)

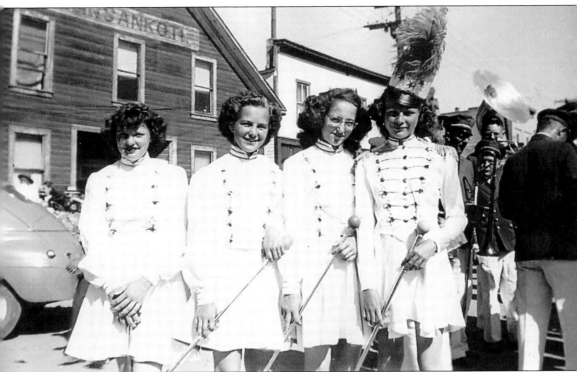

Labor Day was known to be the biggest celebration of the year. Parades, contests for children and adults, sporting events, and food and beverage marked the day. One of the highlights in the parade was the appearance of the Union Pacific Marching Band, directed by James Sartoris. The band was comprised of students and adults, and its march began in South Superior and went all the way to Superior and back. The 1947 parade featured four majorettes who led the band in the parade. They are, from left to right, Bernice Woodhead, Frances Novak, Annie Cristanelli, and LaVerne Carlson. (Courtesy of Flora Tosolin.)

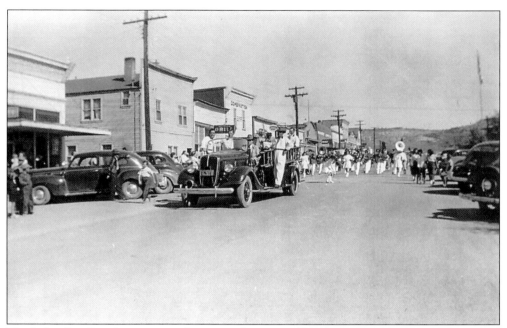

The Labor Day Parade was sure to bring out the town of South Superior's 1937 Ford fire engine and members of the volunteer fire department. The department fought some spectacular fires over the years, which are described elsewhere in this book. (Courtesy of Flora Tosolin.)

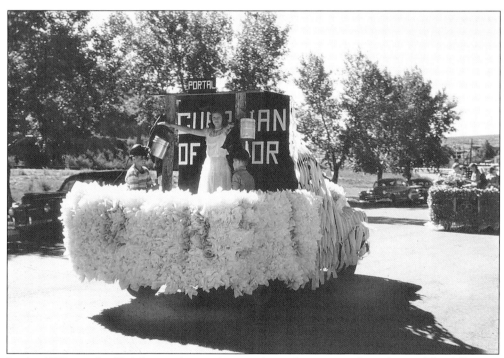

In the 1959 parade, Girl Scouts depicted a guardian of miners as their theme. The following are depicted in this image: a mine portal, miners with hard hats, and a guardian angel holding typical miners' lunch buckets.

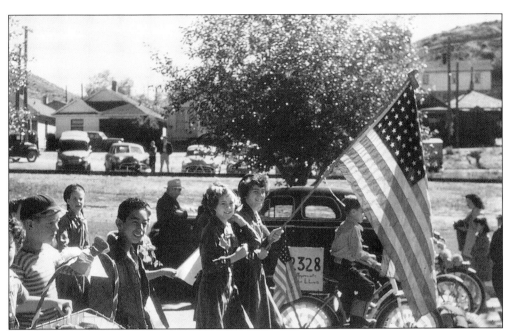

Young Girl Scouts form a color guard in the 1959 parade marching down Front Street. The Labor Day celebration was a very big event in these strongly union communities. Scouts not only participated in their traditional activities but also in these parades and in first-aid contests.

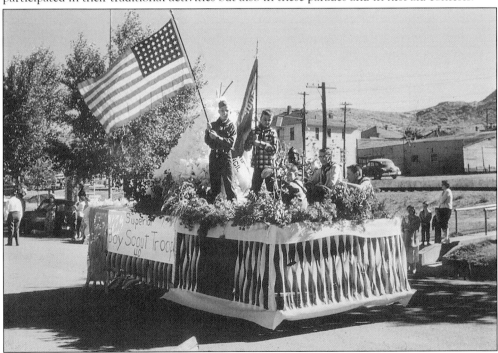

A Superior Boy Scout Troop is also shown at the 1959 Labor Day Parade. The image portrays one of the area's great strengths, the wealth of outdoor activities. The float showcases one of Superior's advantages: easy access to fishing, hunting, camping, and hiking. (Courtesy of the Superior Museum.)

In the summer of 1948, mayor of South Superior Arthur "Cheesy" Chaussart (left) and Jim Draycott show their horsemanship while in the parade on Front Street. A color guard and men who served in the military in both world wars are following close behind. (Courtesy of Flora Tosolin.)

Patty Hardy gets ready to show off her decorated bike in a 1948 parade. With the Union Hall as a backdrop, many youngsters are ready to take off on an hour-long trek. Then, they will be eagerly awaiting refreshments. (Courtesy of Patty Hardy James.)

Eugene Evans was a music teacher at Superior High School. He was also a leader of Superior's Union Pacific Band. Since he directed the high school band, many of his students were also involved with the UP group, as were community adults.

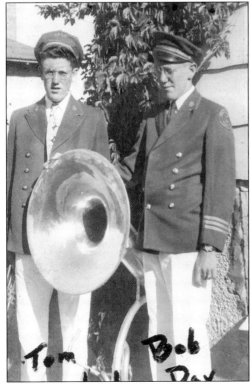

Brothers Tom (left) and Bob Lavery were longtime members of the band as students in high school and as adults. Getting ready to march with the band in a 1949 parade, the brothers joined 50 others to provide music. (Courtesy of Norma Lavery Jordan.)

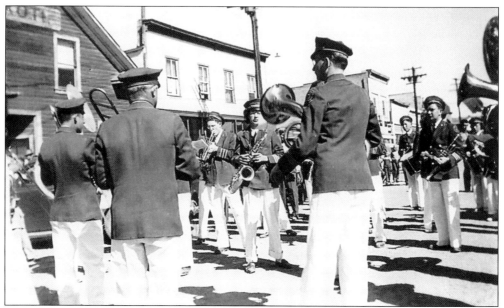

The Superior Union Pacific Band performs on Front Street prior to the beginning 1947 parade. The band was sponsored by the company and was under the direction of James Sartoris, who was also the music director for many other bands throughout the company's communities. (Courtesy of Flora Tosolin.)

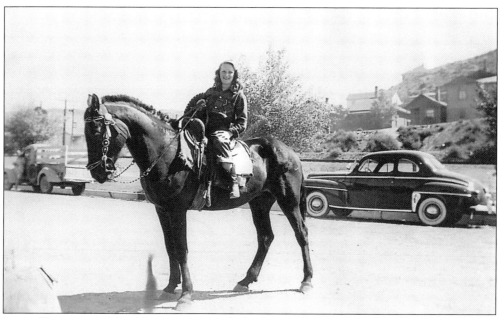

Joann Chaussart and her horse wait patiently for assignment to a 1948 parade on Front Street. Riding ability and a well-groomed horse were, and are, a symbol of an independent Westerner. (Courtesy of Flora Tosolin.)

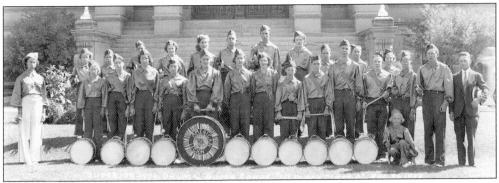

On August 26, 1938, the Superior Drum and Bugle Corps won first place in Class C at a state competition. The group poses on the steps of the Wyoming State Capitol in Cheyenne after winning its trophy. (Courtesy of the Wyoming State Archives, Department of State Parks and Cultural Resources.)

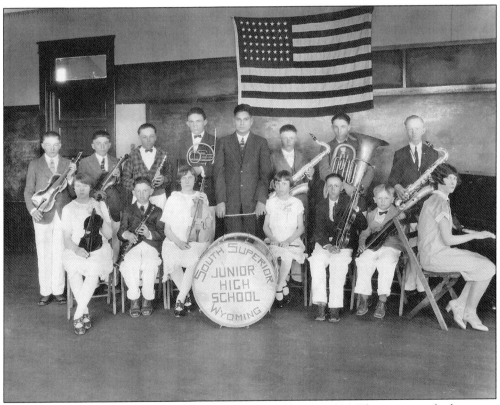

The South Superior Junior High School band is featured here in 1926. The two towns had separate school districts until 1931, when they consolidated. The teacher is Frank Whitetree. Identified in no particular order, the students are Inez Genetti, Bruno Genetti, Charles Profaizer, Monte Berti, Victor Abram, Reino Korhonen, Hollis Hill, Leno Genetti, and Carolyn Hill.

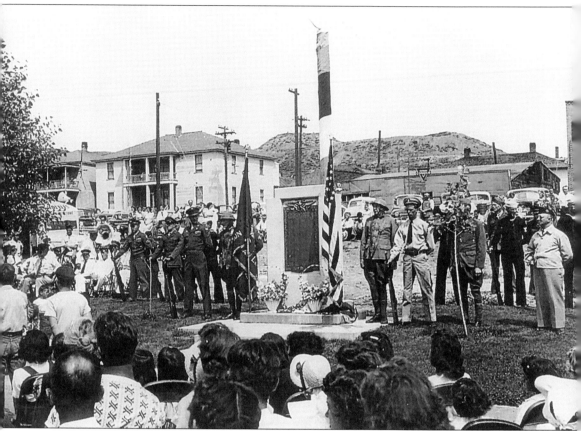

Dedication of the War Memorial took place on South Superior's Front Street in 1949. Twin Cities Post No. 74 of the American Legion erected the monument, which lists 27 who served in World War I and 267 who served in World War II. The monument also identifies those who gave their lives in World War I: George A. O'Neal, Charley Park, and Tom Whalen. In World War II, those who died were Aldo Bertagnolli, Robert Gardner, Bruno Genetti, Patrick Gratton, Rueben P. Haueter, Frank Legerski, John Levkulich, Rollin M. Miser, Frank Nagy, Sidney Payne, Paul Pecolar, Charles W. Price, Wallace H. Richardson, Dario Rizzi, Lee P. Staley, and William G. Thompson. The communities gave a substantial effort to the wars. (Courtesy of Flora Tosolin.)

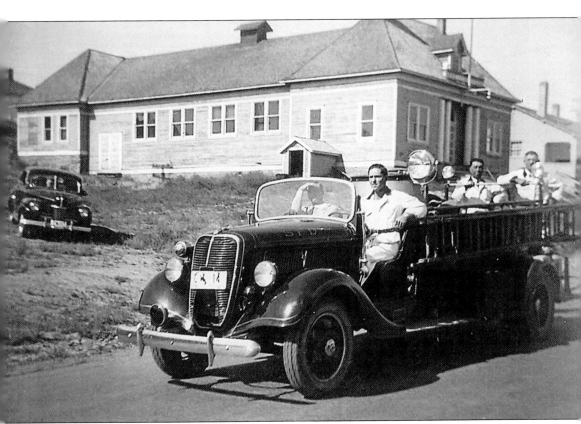

The 1937 Ford fire engine was the pride of the South Superior Volunteer Fire Department. The department saw its share of large fires, including the one in 1962 that destroyed the Superior Opera House, seen in the background. Riding on the rear of the vehicle are Louis Bertagnolli (left) and Max Tosolin, while the driver is John Prevedel. All three men were volunteers. Other major blazes they faced included the Copenhagen tipple fire in 1936 and the Finn Hall fire in 1951–1952. With the volunteers out on a practice run, this image was captured in 1949. (Courtesy of Flora Tosolin.)

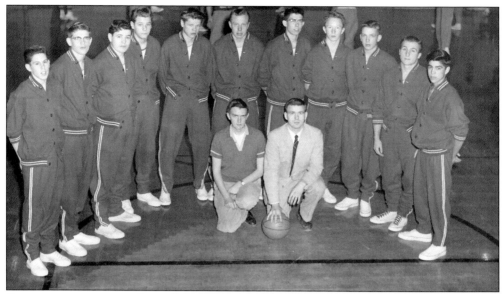

Sports were an important facet of life at Superior High School, which fielded some powerful teams over the years. The 1959 basketball team laid the foundation for later championship squads. The players are, from left to right, Roger Zorco, George McIntosh, Don Mattinson, Dennis Mattinson, Louis Menghini, Marion Larson, Jim Gazdik, Ed Maki, Carl Jablin, and Jerry Torres. In front are trainer Sam Pierantoni and coach Ken Mullen.

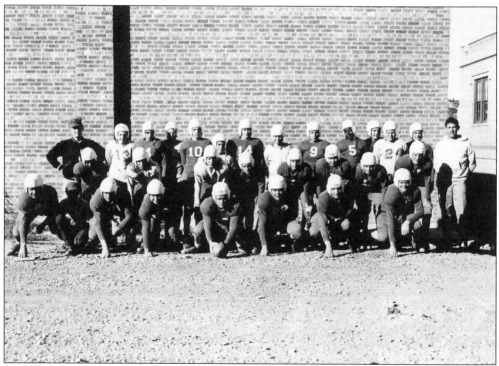

The Superior Dragons football team of 1946–1947 poses near the high school gym. It would be possible to name some but not all of the participants. The team was a formidable member of the Southwest Wyoming Class A Athletic Conference and met with considerable success.

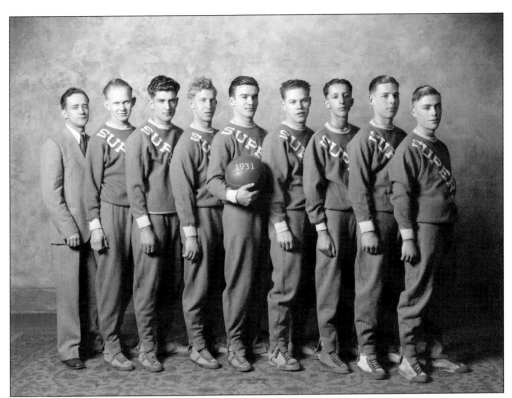

To the 1931 Superior High School basketball team went the honor of being the first team to play in the new gym. Those pictured are, from left to right, coach Lewis Dan Telk, Reino Korhonen, Gus Pandalis, Lawrence Bays, Leno Berti, Fred Novak, Bruno Genetti, Nick Conzatti, and Jack Powell. (Courtesy of the Ludwig-Svenson collection, American Heritage Center, University of Wyoming.)

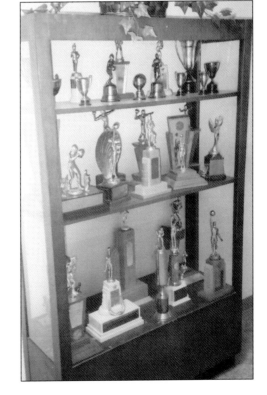

A filled trophy case contains some of many of the trophies won by Superior High School athletes. With the closing of the school in 1963, many trophies went missing. Those shown are housed in the Superior Municipal Building. (Courtesy of the Superior Museum.)

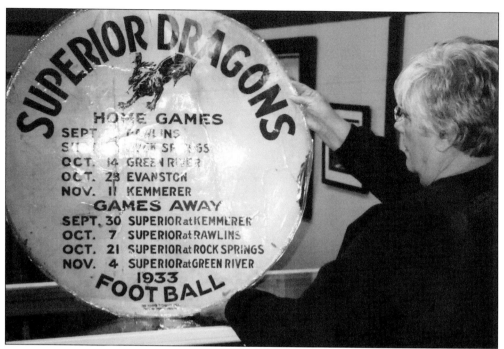

Iris Bonsell holds a drumhead that shows the 1933 Superior High School football schedule. The competition that year was provided by Rock Springs, Green River, Evanston, Kemmerer, and Rawlins. It was a tough schedule because of the size of the schools. (Courtesy of the Superior Museum.)

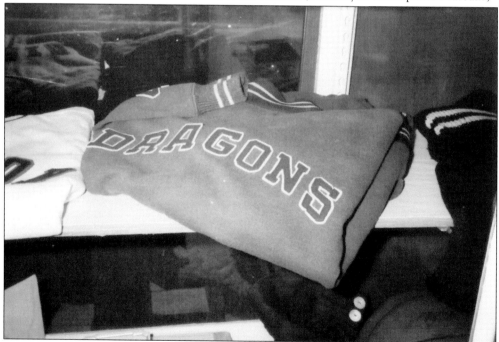

The Superior Dragons wore purple and white uniforms, and the distinctive colors permeated most school activities. A display of uniforms and warm-ups can be seen at the Superior Museum. Even today, at reunions and social events, purple and white appears. (Courtesy of the Superior Museum.)

Superior High School cheerleaders are enjoying a victorious moment. They are, from left to right, Annette Dalpiaz, Sherry Tennant, Bev Bugay, Dolores Lavato, and Patty Kladianos. (Courtesy of Sherry Tennant Pecolar.)

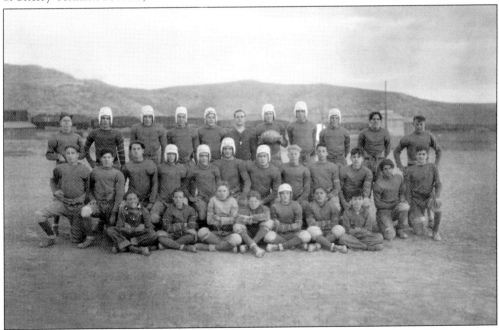

In 1930, the Superior High School football team poses on the dirt-hard football field. There were no fancy uniforms, and they obviously shared helmets, but a great spirit for the sport was evidenced by the confidence shown in this image. Coach Lewis Dan Telk is pictured in the center of the third row. (Courtesy of Hannah Davis Tennant.)

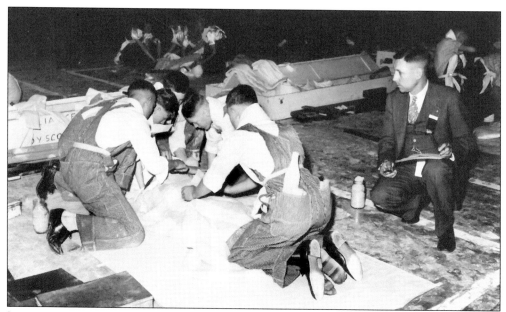

Intense competition marked the annual First Aid Field Day held at the Old Timers' Building in Rock Springs. Teams from mining towns in southwest Wyoming competed for prizes awarded by a safety-minded Union Pacific Coal Company. A judge observes and tabulates the works of an adult team.

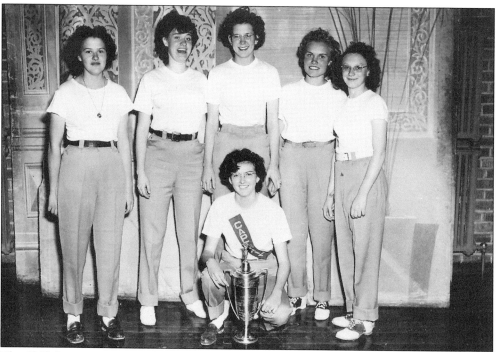

The 1947 Superior senior Girl Scout team won first place in their category. Teams practice all year under the tutelage of a certified instructor. The Girl Scouts are, from left to right, (first row) team captain Margaret Smith; (second row) Loretta Tarter, Gloria Wisneski, Miriam Pietala, Doreen King, and Charleen Odorizzi.

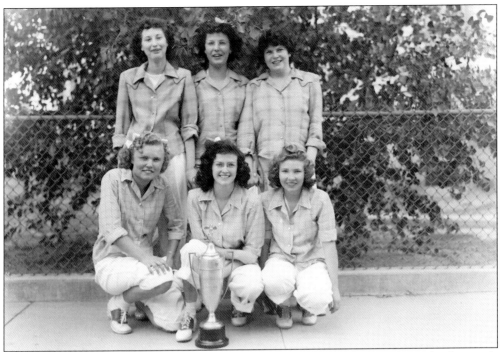

The 1946 senior Girl Scout team from Superior also captured first place. Obviously, these girls are experienced and competitive. The team members are, from left to right, (first row) Doreen King, Margaret Smith, and Vera Morrow; (second row) Hannah Harney, Rosina Casarotto, and Deon Palmer.

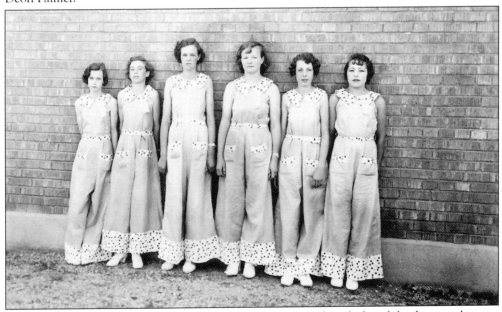

Members of this junior Girl Scout team from Superior are unidentified, and the date is unknown. The outfits worn by the girls are unusual and colorful and probably reflect a style or fad of the time. Hopefully, these young women competed well and won a prize for themselves and their hometown.

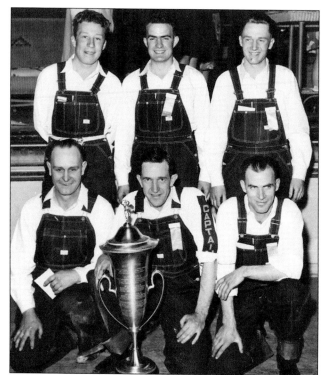

For men in the mines, first aid was serious business, as they practiced not only for the field day but for use in the mine should an emergency occur. The Superior D.O. Clark team won first place in 1942. Those pictured are, from left to right, (first row) Frank Buchanan, Alex Clark, and James B. Caine; (second row) Stan Fabian, Morey Pierantoni, and George Rasmusson.

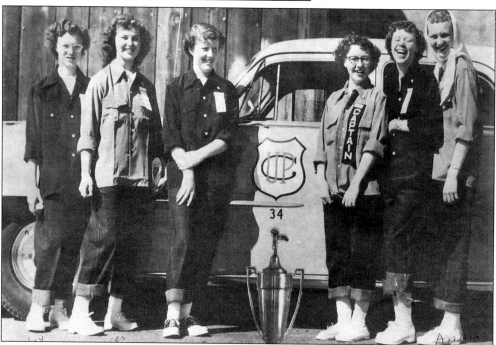

In 1952, Superior Girl Scouts brought home the first-place trophy in their category. They pose before a Union Pacific vehicle, which was also given as a prize though not in this contest. The girls are, from left to right, Shirley Hiner, Frances Novak, Norma Lavery, Lois Draycott, Carma Robinson, and Annie Pritchard. (Courtesy of Norma Lavery Jordan.)

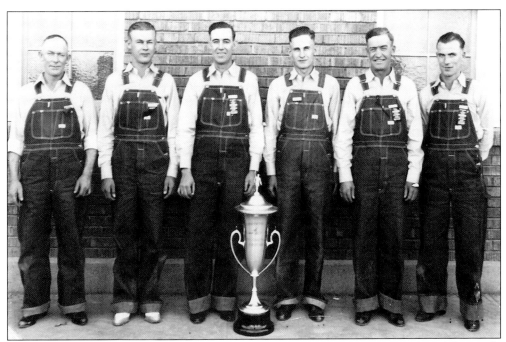

The men's team winner from Superior in 1937 is pictured in typical men's uniforms—bib overalls and white shirts. In this image are, from left to right, Tom Robinson, Harold Massie, Sam Gillilan, Bill Lahti, George Noble, and George Caine.

The senior Boy Scout winner in 1935 was the Superior team. First aid is an integral part of the Boy Scout program, which helps ensure safer Scouting adventures. The team members are, from left to right, Malcolm McCleod, Hale Law, Paul Petrina, unidentified, Mike Legerski, and Laddie Tremelling.

Safety was of paramount importance in the employee magazine's featured stories and images of potential accidents. Lenses and goggles worn by Claude Hiner in 1938 were publicized because a large piece of steel broke from a lathe and struck Hiner's safety goggles. A devastating injury was prevented by the protective eyewear.

In the same year, a six-ton locomotive ran over Kaiser Elich's foot in Reliance. Because of a steel-reinforced boot, there was no injury. These examples were featured to drive home the point that a miner being responsible was essential to a safe workplace.

The Sentinel of Safety trophy was awarded each year to the mine in the United States that worked the most hours without a lost time accident. The small statuette was cast in bronze and depicted a young mother with a child in her arms, both awaiting the safe return of the head of the household. The US Bureau of Mines issued the award each year in a national safety competition. Superior B Mine won this trophy in 1933, Superior C Mine in 1934, Superior D Mine in 1937, and again Superior B Mine in 1939. Superior D Mine won the award in 1943, having worked 307,529 man-hours without a lost time accident.

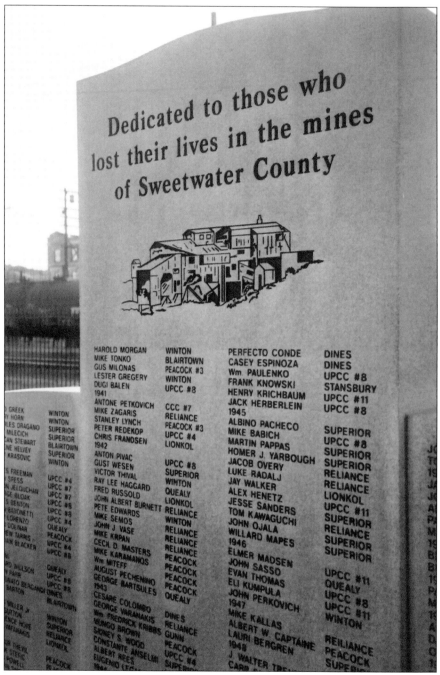

The monument lists names with associated mine locations:

Name	Location
HAROLD MORGAN	WINTON
MIKE TONKO	BLAIRTOWN
GUS MILONAS	PEACOCK #3
LESTER GREGERY	WINTON
DUGI BALEN	UPCC #8
1941	
ANTONE PETKOVICH	CCC #7
MIKE ZAGARIS	RELIANCE
STANLEY LYNCH	PEACOCK #3
PETER REDEKOP	UPCC #4
CHRIS FRANDSEN	LIONKOL
1942	
ANTON PIVAC	
GUST WESEN	UPCC #8
VICTOR THIVAL	SUPERIOR
RAY LEE HAGGARD	WINTON
FRED RUSSOLD	QUEALY
JOHN ALBERT BURNETT	LIONKOL
PETE EDWARDS	RELIANCE
MIKE SEMOS	WINTON
JOHN J. VASE	RELIANCE
MIKE KRPAN	RELIANCE
CECIL D. MASTERS	RELIANCE
MIKE KARAMANOS	PEACOCK
Wm MITEFF	PEACOCK
AUGUST PECHENINO	PEACOCK
GEORGE BARTSULES	PEACOCK
1943	QUEALY
CESARE COLOMBO	
GEORGE VARANAKIS	DINES
Wm FREDRICK KRIBBS	RELIANCE
MUNGO BROWN	GUNN
SIDNEY S. WOOD	PEACOCK
CONSTANTE ANSELMI	UPCC #4
ALBERT REES	SUPERIOR
EUGENIO LEC...	

Name	Location
PERFECTO CONDE	DINES
CASEY ESPINOZA	DINES
Wm PAULENKO	UPCC #8
FRANK KNOWSKI	STANSBURY
HENRY KRICHBAUM	UPCC #11
JACK HERBERLEIN	UPCC #8
1945	
ALBINO PACHECO	SUPERIOR
MIKE BABICH	UPCC #8
MARTIN PAPPAS	SUPERIOR
HOMER J. YARBOUGH	SUPERIOR
JACOB OVERY	SUPERIOR
LUKE RADALJ	RELIANCE
JAY WALKER	RELIANCE
ALEX HENETZ	LIONKOL
JESSE SANDERS	UPCC #11
TOM KAWAGUCHI	SUPERIOR
JOHN OJALA	RELIANCE
WILLARD MAPES	SUPERIOR
1946	SUPERIOR
ELMER MADSEN	
JOHN SASSO	
EVAN THOMAS	UPCC #11
ELI KUMPULA	QUEALY
JOHN PERKOVICH	UPCC #8
1947	UPCC #11
MIKE KALLAS	WINTON
ALBERT W. CAPTAINE	
LAURI BERGREN	REILIANCE
1948	PEACOCK
J. WALTER TRE...	SUPERI...
CARR A...	



Name	Location
...D GREEK	
...Y HORN	WINTON
...LES DRAGANO	WINTON
...MILECICH	SUPERIOR
...AN STEWART	SUPERIOR
...NE HELVEY	BLAIRTOWN
...KRASOVIC	SUPERIOR
	WINTON
...S FREEMAN	
...SPESS	UPCC #4
...N JELOUCHAN	UPCC #7
...GE BUDAK	UFCC #7
...S BENTON	UPCC #8
...BABONETTI	UPCC #8
...LORENZO	UPCC #4
...DOLNAR	QUEALY
...EW TARRIS	PEACOCK
...AM BLACKER	UPCC #4
	UPCC #8
...PD BILLSON	QUEALY
...Y PARR	UPCC #8
...NARO BERGANDI	UPCC #8
...BARTON	DINES
...MILLER Jr	BLAIRTOWN
...BUTTON	WINTON
...ENCE HUTE	SUPERIOR
...VARNAKIS	RELIANCE
	LIONKOL
...UR THIEL	
...R STEENE	
...POWELL	PEACOCK

Over 400 names are inscribed on a monument erected in Rock Springs in October 1997 that commemorates the miners who gave their lives working in the mines of Sweetwater County. Of these 400, eighty-four were victims in mines at Superior. The monument was erected to list miners from 1888 to 2005. While no single big explosion killed a large number of miners in Sweetwater County (Superior included), deaths occurred one, two, or three at a time because of cave-ins, mechanical failures, or other causes. Fatalities declined over the years as companies and unions worked to create safe places. The Superior fatalities listed occurred from 1906 until 1963.

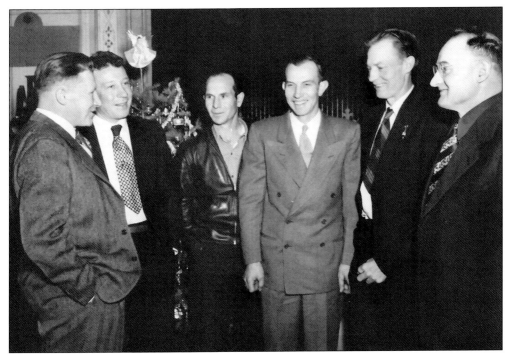

At a December gathering, Union Pacific safety engineer Frank Peternel (far left) chats with, from left to right, Stan Fabian, foreman of 7 Seam; Fred Flohr, unit foreman of 7 Seam; Leon McGee, unit foreman of 9 Seam; and Otis Jones, unit foreman of 7.5 Seam. All these men were from the Superior D.O. Clark Mine. Also pictured is Sam Evans (right), foreman at Reliance.

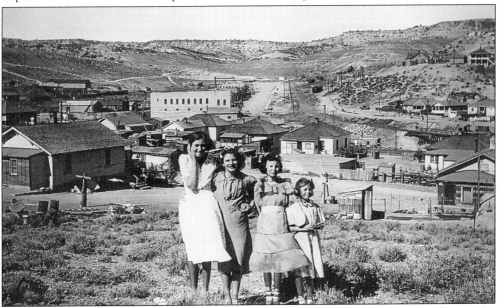

On a windy day on a hill, the Tosolin sisters and an unidentified friend are standing in the foreground of a panoramic view of South Superior, with Front Street directly behind them. To the left in this 1941 image is the B Mine. The ridge forms the background and the boundary of Horse Thief Canyon. (Courtesy of Flora Tosolin.)

Frank Prevedel Sr. sits in his 1925 Dodge Roadster, while the Menghini family sits on the running board near their home on C Hill. The family includes, from left to right, Costantina, Leno, Ida, and August, and Edigio. The adult Menghinis had immigrated to Superior from the Tyrol in the early 1920s. (Courtesy of Leno Menghini.)

Dick Arkle and his daughter Marvel proudly show his new Dodge sedan in 1931. Prior to the Great Depression, many residents owned automobiles, as other forms of transportation did not exist. There are many tales about how certain brands of cars had to be put into reverse to climb Superior's hills.

"All dressed up and nowhere to go" was a saying popular among young residents in Horse Thief Canyon in 1926. So these enterprising young people would dress in their finery to go to church. Then, for a lark, they would tour different mine sites in the area, with photographs taken for posterity. Those pictured are, from left to right, Tom Lavery, Florence Menghini, Edith Profaizer, and two unidentified people. (Courtesy of Norma Lavery Jordan.)

The Tosolins, who came to the United States in 1917, enjoy a Sunday afternoon with friends during a 1936 outing on one of the many unimproved roads surrounding Superior. Dressed in Sunday attire, they, too, are exploring the area. (Courtesy of Patty Hardy James.)

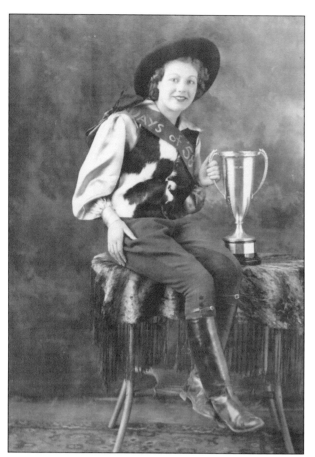

Lorene Arkle of Superior was named queen of the day at a 1958 celebration in Rock Springs. Although the county's major occupation was mining rather than agriculture, the 1937 celebration featured cowboys and cowgirls of the Old West.

The first grade is a splendid place to observe Easter with bonnets and a pastel display. Thelma Faddis was the first-grade teacher in 1949, and her students are entertaining parents and friends on the high school stage. (Courtesy of Patty Hardy James.)

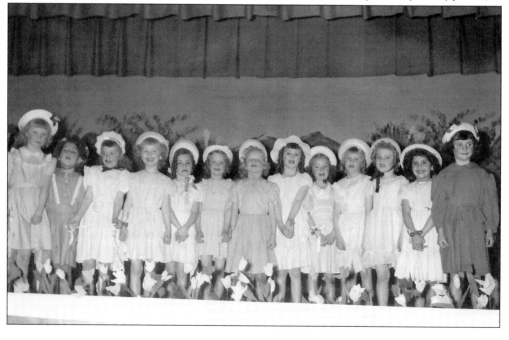

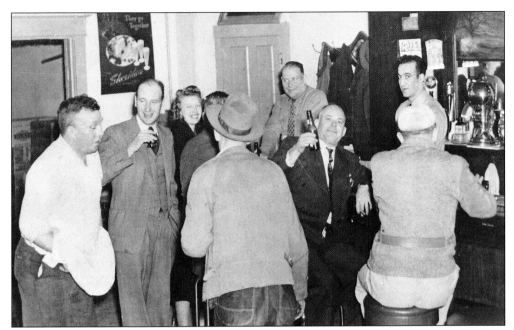

This image of the inside of a bar in 1948 possibly points to one event—the election in which Harry Truman won a great victory, assisted by a very heavy Democratic vote in the canyon. The Combination Bar celebrants are, from left to right, (facing camera) Don Shaw, John Tennant, Elsie Maki, Joe Lorenzon, Shorty DeCroo, and Murdock McLean; (backs to camera) unidentified, unidentified, and Primo Marietta.

Arthur "Cheesy" Chaussart, owner and operator of the Superior Meat Market, was mayor of South Superior when he was elected as a Sweetwater County commissioner. He was the first resident of the canyon to be elected to that position. He served from 1949 to 1953.

Upon the death of her husband, Catherine Chaussart was appointed to fill the term to the next election, which she won. She served a full term in 1956. She was the first woman to be elected to the Sweetwater County Commission. Catherine served from 1953 to 1961 and as chairperson from 1959 to 1961.

The Old Timers' Building, constructed out of respect for longtime employees of the Union Pacific, was the scene in 1943 of a banquet honoring the winners of that year's Sentinel of Safety award. The miners of Superior's D Mine were feted for receiving the award.

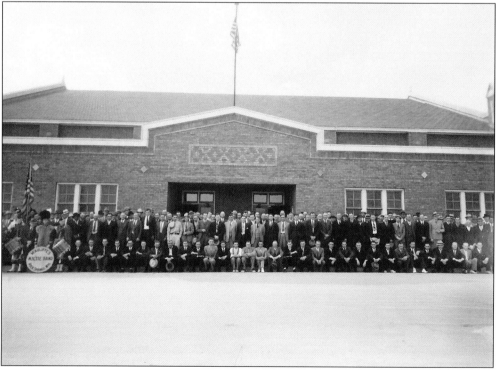

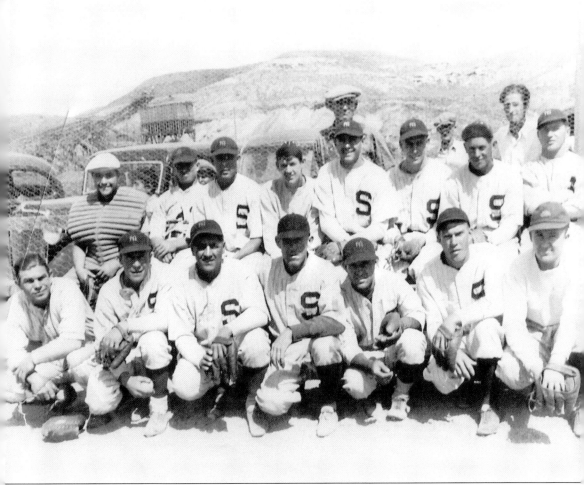

The Twilight League was a men's baseball program, with companies sponsoring adult teams. Men were sometimes assigned jobs that would allow for absences and for practices. Many towns in the region encompassing Wyoming, Colorado, and Utah would compete. In 1935, the Superior Twilight League players wear newly acquired uniforms and pose for this picture. The uniforms were purchased from the New York Yankees when Tom Lavery answered an ad to acquire them. Florence Lavery carefully removed the NY and substituted the letter S on the pinstripe uniforms. The caps in this image, however, still bear the venerable interlocking "NY." The New York Yankees Museum in New York was searching for paraphernalia from the Superior transaction and has put this image on display in the museum at Yankee Stadium. (Courtesy of Bob Lavery.)

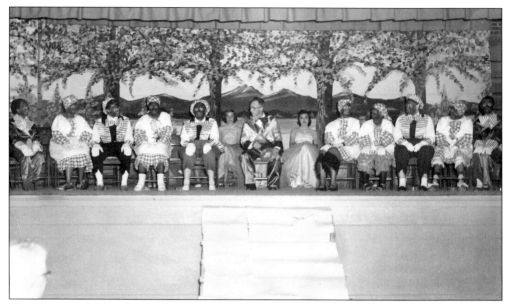

Congregational Church members appear in a minstrel show in a 1954 production led by Rev. David Choate (center). Members are shown on the Superior High School stage. (Courtesy of Margaret Arkle Bettolo.)

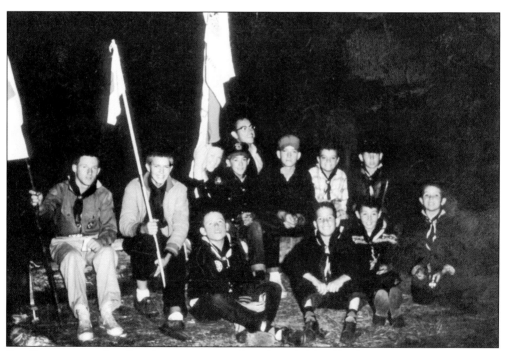

Boy Scout troops played an important part of youth activities. Outdoor camping opportunities abounded in the area and at the New Fork Lake Scout camp in the Wind River Mountains. This troop is camping at New Fork Lake in 1958.

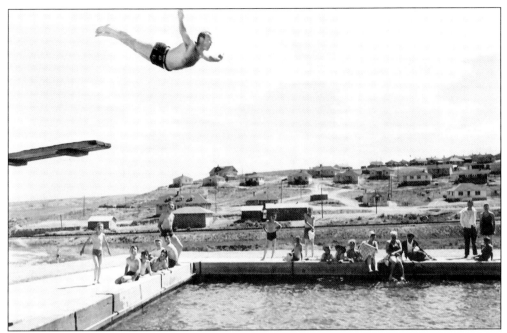

Grant Rhiner, a high school teacher, is finding a way to spend a hot summer afternoon in 1946 and is demonstrating to young admirers how diving should be done at the Superior pool. Seen in the background is a portion of B Hill, a major residential area. The pool was begun as a WPA project in 1935 and closed in the late 1960s.

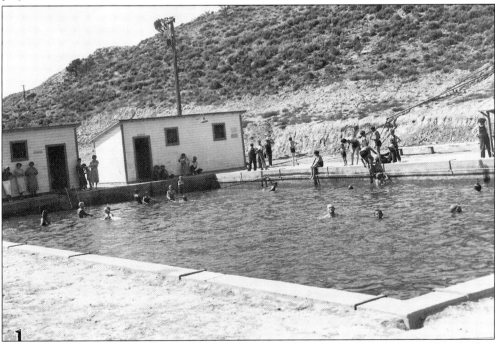

Here, both adults and youngsters are enjoying the pool. The WPA built the majority of the facility, but community effort completed it. The pool was in use for over 30 years. Water pumped from the mines was used to good advantage in filling the pool.

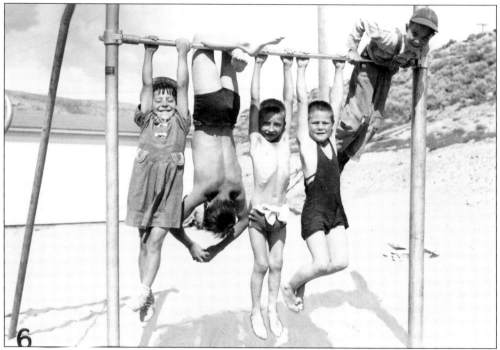

When the WPA built the school stadium and began work on the pool, they also built extensive play areas adjacent to a park, which included the pool complex. Children were attracted to the park, the pool, and the playgrounds in large numbers. Here, the bars provided a photographic opportunity.

The boys' Sunday school class at the Union Community Church was very active under the direction of James Haueter. In 1931, in addition to the school, services were held regularly. Several religions were present as an umbrella for Protestant activities.

Several girls from the Union Sunday school pose with their adult supervisor and appear in their 1931 best. No one is identified, and no exact date is given. Almost everyone, however, is wearing a coat, and the young lady without one looks cold. Sunday school appears often in images in the Sweetwater County Museum collection.

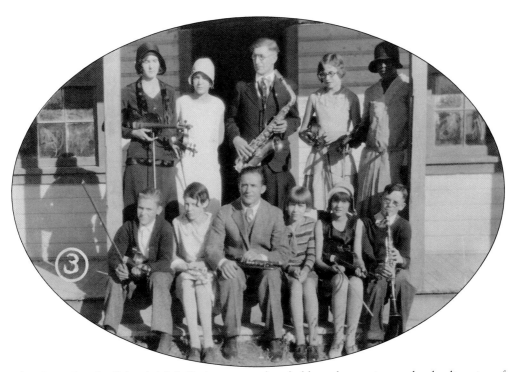

The Union Sunday School Adult Orchestra members held regular services under the direction of James Haueter (first row, center) and were active at the time of this 1931 image. They met at the Community Church Building. It appears church activities appealed to several age groups.

This Union Sunday school class poses on the portico of the church. The photograph is of interest because of the dress of the time. Note the caps and knickers, and many boys are seen in overalls. James Haueter (far left) seems to have some success in attracting young people to the church.

These three leaders were largely responsible for the establishment of the Congregational Church building in Superior and its remodeling from a medical clinic to a church compound. Seen in this image are, from left to right, Marvel Arkle, Jane Choate, and Rev. David Choate. (Courtesy of Margaret Arkle Bettolo.)

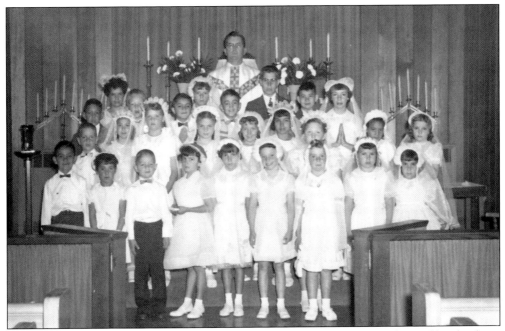

First Communion, an important event in the Catholic Church, is celebrated in 1955 with a large class. Rev. Aloysius Diekemper presided over the ceremony. The large size of the class showed the vitality of the parish. (Courtesy of Margaret Arkle Bettolo and Patty Hardy James.)

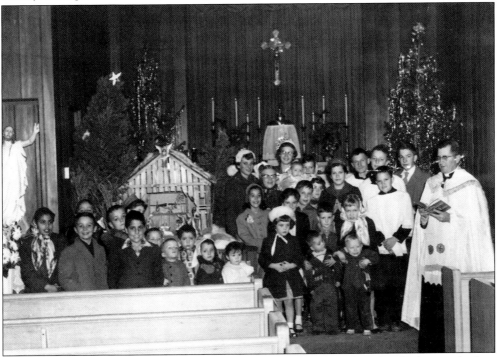

Christmas 1955 is a busy time for the youth of St. Vivian's Parish, with Father Diekemper leading the way. Traditional carols and a Christmas message are delivered to parents and other members. (Courtesy of Marcella Williams Romero.)

A 1948 Brownie troop looks businesslike at a meeting at the clubhouse. The girls are, from left to right, (sitting) Joan Retel, Bev Morrow, Sharon Waters, and Sherry Tennant; (standing) Rosemary Foianini, Isabel Lucas, Mary Roberts, Donna Woodhead, Mary Normington, Betty Odorizzi, Shirley Waters, Sandra Pierantoni, and Sue Bowen. (Courtesy of Sherry Tennant Pecolar.)

The class of 1958 dances the night away at the annual junior prom. For high school students, the prom was the social highlight of the year, with formal dress and corsages the attire of the day. The dance was usually preceded by dining at a favorite restaurant.

Many classes and seminars were on the schedule for spouses in the mining community of 1931. One such class taught at the Superior High School was in home decorating. The high school home economics room was the class setting.

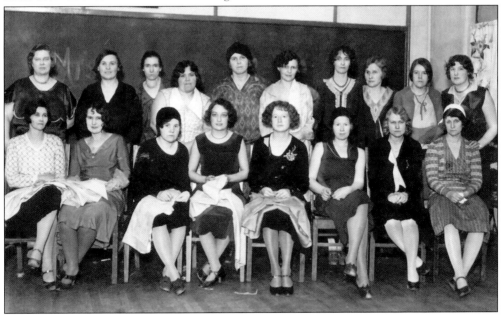

Sewing classes were popular, and images of such classes appear often in the Sweetwater County Museum's collection. The high school provided the room, the machines, and the instructor. In 1931, with the approach of an economic downturn, making clothes was an asset and a necessity.

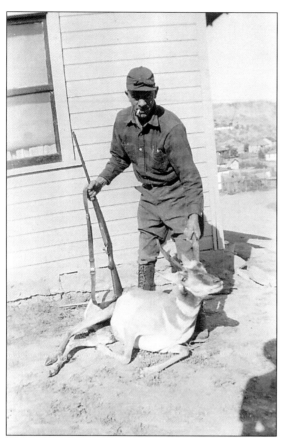

The 1948 hunting season provided Max Tosolin with this pronghorn, or antelope, as they are called. Big game, such as elk and deer, were common in the area and provided hunting, recreation, and sometimes a supply of food for the winter. (Courtesy of Flora Tosolin.)

Winter 1926 must have been one to remember, judging by the images left of the snowfall. Families seem to be snowbound. In this dry climate, this much snow is not usual today, or perhaps things have moderated a great deal since then. The weather did create a neighborly bond.

A Wyoming winter in 1926 could be brutal at an elevation of 7,000 feet. A school bus is navigating a newly opened route to provide students access to school. Although winters have eased considerably, tales of weather in the "good old days" seem to be given credence with images like this.

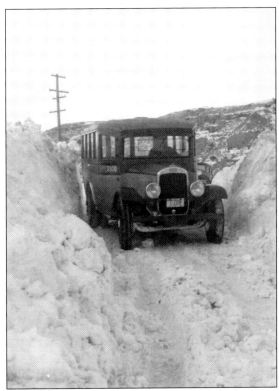

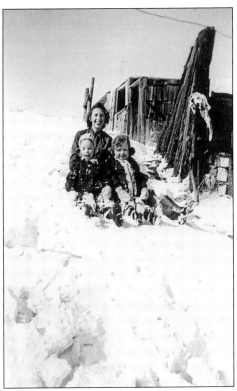

Patty Hardy (left) and Carol Beckstead enjoy sliding down a hill in the winter of 1947. Their Aunt Flora is enjoying the day with the girls. Such winter scenes were the norm in the hilly area and provided much entertainment. (Courtesy of Flora Tosolin.)

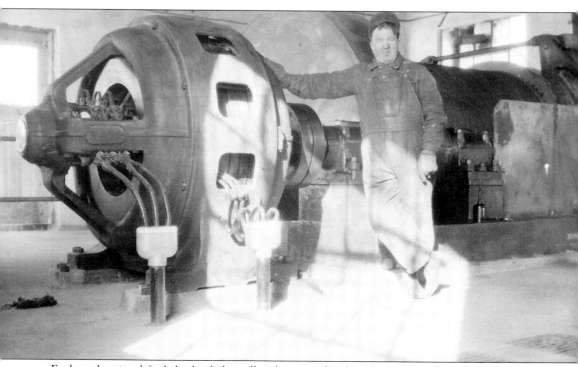

Each early mine lifted the loaded small railcars up the slope by a steel cable. Empty cars were lowered by a cable to allow for production below. This system required an experienced miner who would respond to signals from below to pull, stop, or lower the cars. The hoist required a powerful motor and very strong cable. Constant inspection of the cable was required. Pictured here around 1929 or 1930, John McCarty Davis was a hoist operator at C Mine. (Courtesy of Hannah Davis Tennant.)

Five

ALMOST A DEATH KNELL

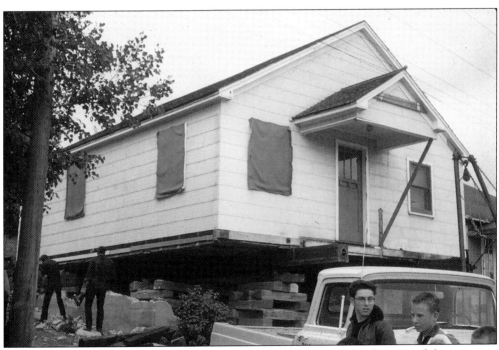

With Superior and South Superior facing very difficult economic times because of closing mines and lost jobs, many people decided to buy a reasonably priced Union Pacific house and move it elsewhere. Some chose to move their own house to Rock Springs or points beyond. This home is being prepared for movement in 1959.

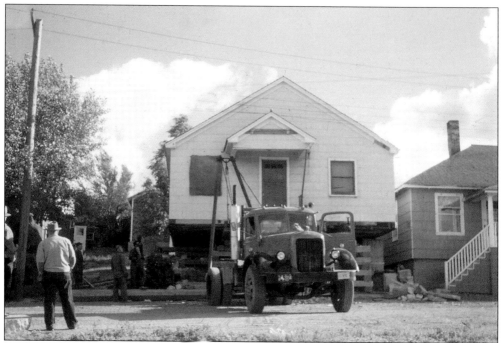

Loaded on a truck, the house is ready to leave. This sight was repeated hundreds of times, according to Dudley Gardner's book *Forgotten Frontier.* Houses left mining communities and were moved to locations where the former miner hoped to settle or where the house could be upgraded and sold.

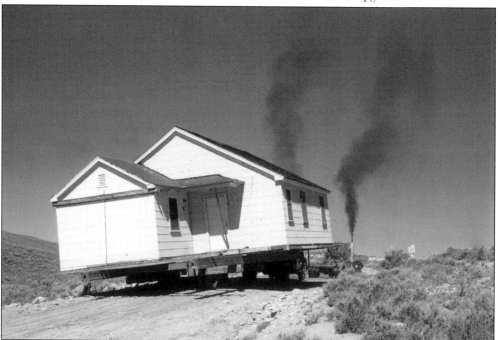

As the house left town, two trucks—one carrying the house and the other pulling it up steep inclines—headed due west across a rough, unimproved road, 11 miles to Winton. After reaching pavement, this house journeyed south another 11 miles to its destination in Rock Springs.

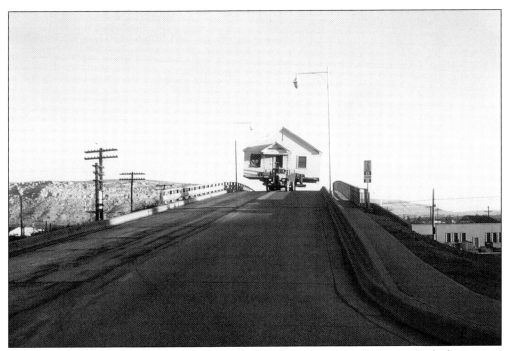

After reaching Rock Springs, the house passed through streets where electric and telephone wires were raised to assure passage. A house traveling the A Street Overpass in downtown Rock Springs was viewed by hundreds of curious residents, who likely wondered about its destination.

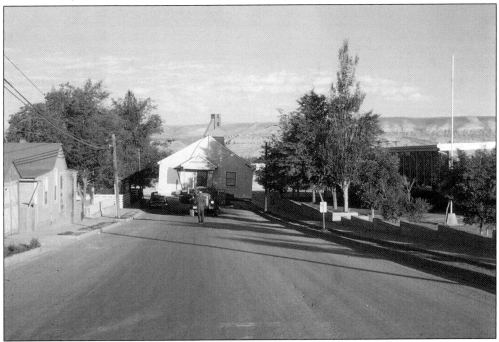

The house reaches Edgar Street in southeast Rock Springs, with Lincoln Elementary School on the right and with several more blocks to go to the edge of town for final placement. This two-day move is nearly complete.

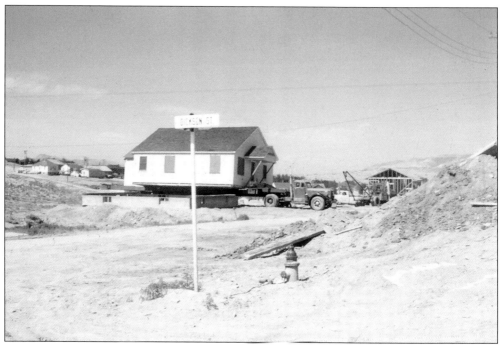

Placing the house carefully on a foundation poured earlier was a taxing job. A false move or a hard drop could lead to damage. At this time, the neighborhood is isolated and at the edge of the city. That would soon change, as the area developed quickly.

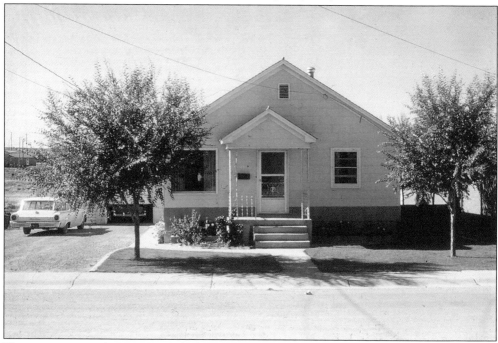

The move was complete in 1960, with the neighborhood established and landscaping and pavement in place. The house is once again livable. It had moved from a community where demand for housing did not exist to one where the building could be put to good use.

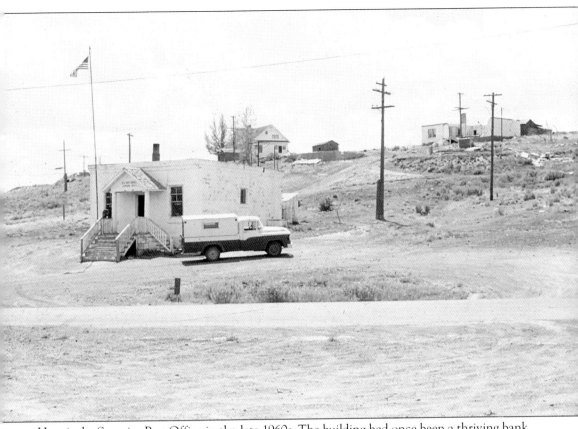

Here is the Superior Post Office in the late 1960s. The building had once been a thriving bank. The site was on Superior's main thoroughfare, and a Union Pacific Coal Company Office, the home of the superintendent of mines, the Superior Opera House, and the clubhouse once flanked this building. Across the street is St. Vivian's Church. Behind the post office was where hundreds of houses owned by the company once stood. The only intact structure seen other than the post office is the teacherage, above and behind the post office. The other building visible is being demolished at right.

A building once used for storage and equipment repair is abandoned, boarded up, and will soon be sold for salvageable lumber. This scene was a common one, and lumber became available to buyers at a very reasonable price. One resident remarked that it was like vultures descending.

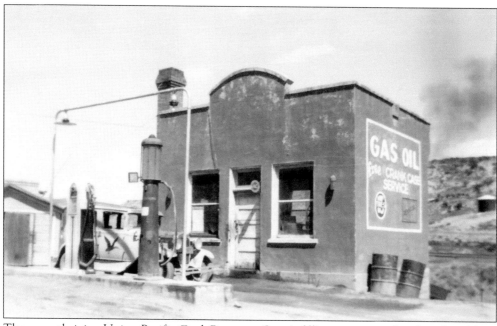

The once thriving Union Pacific Coal Company Store's filling station is abandoned and later will be demolished. It was a sad sight to be sure to witness a once well-kept structure, formerly bustling with activity, now abandoned to the economics of the time.

The Rock Springs Fuel Company's Copenhagen mine no longer had need for a storage unit for mine lamps and batteries. The building slowly fell into disuse and later, with the very rapid closure of facilities throughout the town, became a target for demolition. Structures such as these disappeared without a trace.

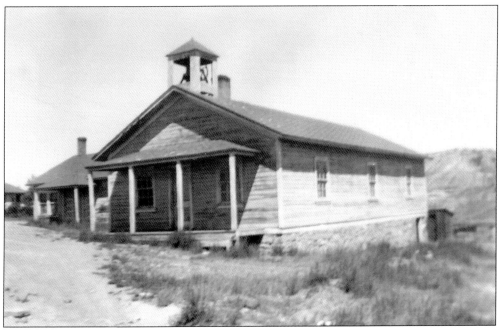

The proud community church, which is featured in a 1915 image in this book, had run out of members by 1963. In need of repair and paint, it also fell victim to the hammer of a salvage effort and provided good, cured lumber to be used again.

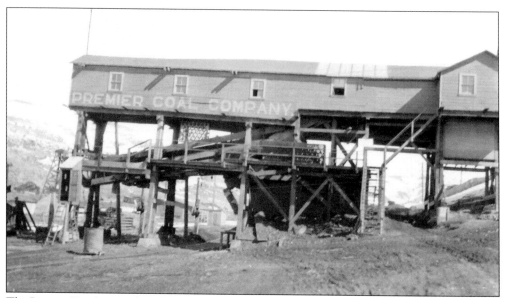

The Premier Tipple, once busy loading tons of coal, fell victim to a lack of a market for the product. The former bustling activity gave way to a forlorn building, quiet and abandoned. Where men and machines had occupied the structure, now silence and a prevailing wind remain.

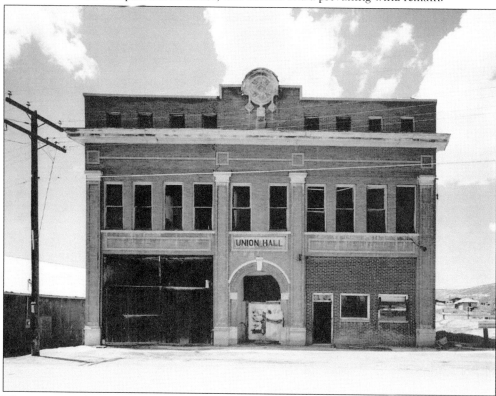

The once proud Union Hall, built in 1921 by the labor unions, gradually deteriorated. It was boarded up and suffered broken windows and a gradual sinking into the creek bed behind the building. It languished until 1993, when a rescue effort began to save it.

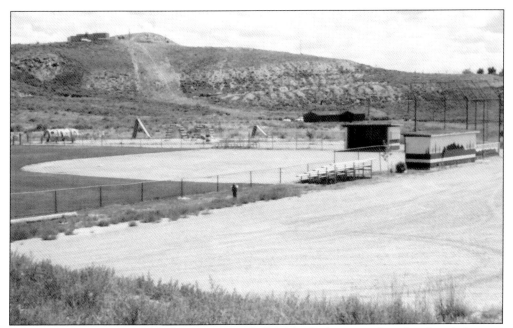

The weed-overgrown outfield of Superior's baseball field tells the story of an abandoned play area that is no longer used or needed. Most youth and adult activities were suspended, and maintenance ceased. The government of the town of Superior by resolution ceased to exist.

The old stadium seating (left) overlooks the former football field, with weeds encroaching on the playing field. Now, the seating is gone, as is the fencing. When the school district and the town of Superior ended in 1963, a government entity in charge was gone. It took a new school district and a different town before corrective action was taken.

A major workhorse inside the mine was a six-ton electric motor, which hauled cars of coal to a dump to be taken to the surface. When the Union Pacific Coal Company closed its last big mine in 1963, these huge engines, or motors as they were called, simply sat on the surface abandoned.

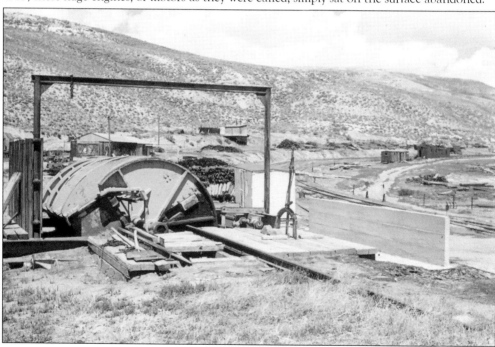

An exterior dump sits idle after the 1963 shutdown. Once used to send refuse picked from the coal into a truck for disposal, its inactivity is indicated by missing tracks. Small coal cars loaded with debris would enter the dump, which would roll 180 degrees to empty.

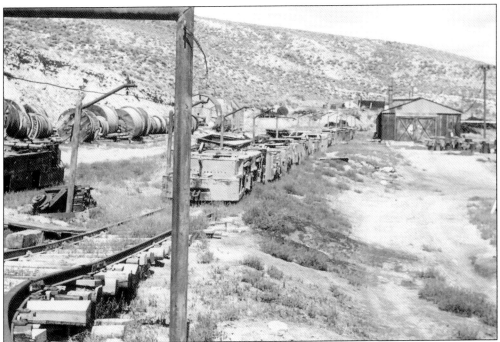

The smaller motors, along with many rolls of copper wire and tons of rail, await their fate in the yards of the closed D.O. Clark Mine. Once workhorses hauling coal, material, and men to the far reaches of the mine, they now sit deserted.

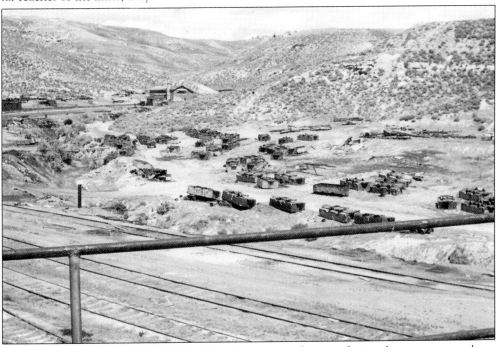

The small yellow coal cars, mainstays of haulage in an underground mine, lie strewn over a large area. These cars hauled an untold number of men to their workplace, coal to the belt for movement to the surface, and supplies for efficient mining.

117

This photograph shows the last vestiges of the once mighty D.O. Clark Mine, as seen in 1963. The partly covered portal is in the foreground. The other buildings are, from left to right, the shops, the bathhouse, and the mine's office. The only activity appears to be at the office, with the other structures being vacant. Each of the buildings was either destroyed or salvaged for the steel or lumber available. In the preceding images, the millions of dollars worth of equipment, which provided for tremendous coal production, was sold for scrap. The tipple itself was dismantled and suffered the same fate.

A trio of crosses marks three graves whose occupants died in 1918, 1920, and 1921. Many graves in the old cemetery are marked; others are not. Graves date as far back as 1908 and belong to a variety of ethnic groups, giving testimony to the diverse population in early Horse Thief Canyon. Many babies, especially during the 1918 flu epidemic, are in evidence. The last burials were dated 1924 to 1925.

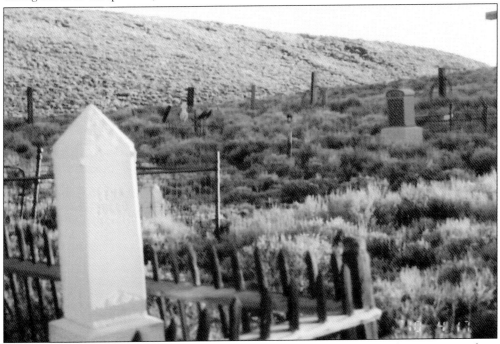

Another view of Superior's Mountain View Cemetery shows marked graves and empty spaces where wooden or sandstone markers have long disappeared or deteriorated. Starting in 1994, however, a new section was added to the once abandoned ground, and new graves are now in evidence.

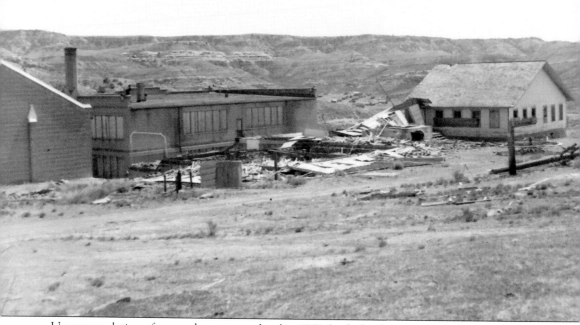

Upon completion of a new elementary school in 1952, both the Superior Elementary School and the South Superior Elementary School were sold or demolished. The image of the elementary school (right) being destroyed is a reminder that about 10 years later the high school (at center) and its gym (left) would suffer a similar fate when School District No. 8 ceased to exist, thus ending over 40 years of high school education in Superior. The schools are often the center of community activities, and the new Superior Elementary School provided that activity until it, too, was closed in 2003. Today, all students from Superior, Thayer Junction, and Point of Rocks are bused to Rock Springs. The former school building now houses municipal offices, a senior center, a library, and a museum.

Six

SURVIVAL AND AWAKENING

Residents Gary Kempton (left) and Jordan Crane welcome visitors to Superior in 2010. Flanking the "Welcome to Superior, Live Ghost Town" sign, the two young men display the openness and vitality of a young population. The live ghost town motto reflects a positive belief that after all the economic distress, Superior will survive with optimism.

Front Street Park hosts a caboose from the Union Pacific Railroad as a reminder of the days when trains traversed the area. A park bench that commemorates one of the Superior all-class reunions sits nearby. Town hall is visible above the caboose.

When the B Mine (see page 11) closed, the stone portal entrance was rescued and placed in a park. Although in a benign setting, the portal is a reminder of the times when men passed through to jobs underground.

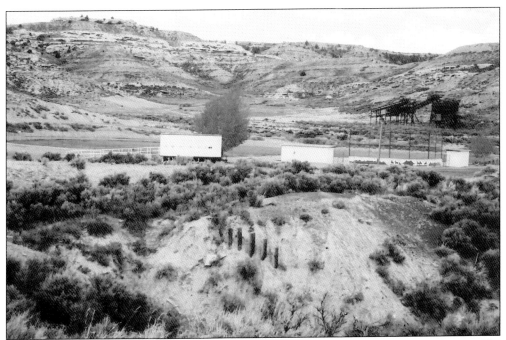

Where earlier weeds and dirt existed, a revived play area blossomed into grass and trees. The foreground shows the remains of a trestle where the railroad once passed. The Copenhagen tipple is in the background. The site has been developed into Marskey Park.

The view is from the canyon, looking south to Black Butte in the distance. Several new homes are visible in the newly developed Coble addition. The subdivision was developed by use of a special county sales tax, which enabled Superior to expand. State senator Marty Martin, showing confidence in Superior, built a home where he and his family now live.

A spacious new home was built overlooking a portion of town that several years ago saw houses being moved out or dismantled. This new residence is a total turnaround from activities of the last several years. The McCormick home is a testament to faith in the future.

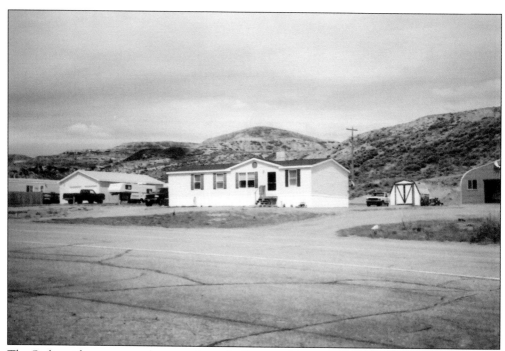

The Stolt residence, across the street from the Superior Municipal Building, is one of several new homes in the community. For those who feared that Superior would not survive, this house and its neighbors are a welcome sight.

The Coble residence is at the north end of a subdivision on Main Street. The home is not far from the Copenhagen tipple, and an outcropping of coal can be seen above the house. Now surrounded by lawns and trees, it is located where new and old exist side by side. (Courtesy of Leno Menghini.)

The Prettyman home, near the area where C Mine tipple once stood, occupies a picturesque spot directly under a stone S (upper center), which was placed by students of Superior High School years ago. With room to expand, this is an area where horses can be kept.

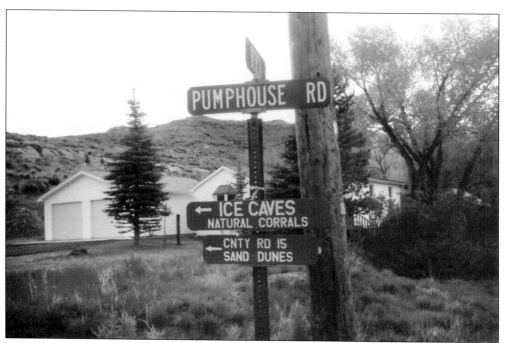

Pumphouse Road in southern Superior leads to several landmarks. First, at the top of the ridge are the wells for the town's water supply. Then, the ice caves and the Natural Corrals can be found in the area. The road also leads to another geological phenomena, the sand dunes.

Wild horses are plentiful in the area and are a gorgeous sight. The horses are remnants of herds that have been wandering free on the range for years. This small group, photographed just outside of town nearly 50 years ago, is echoed by herds today. (Courtesy of Iris Prevedel Bonsell.)

The Superior Memorial Garden is situated adjacent to the old cemetery. Residents and former residents have placed stones to remember loved ones or acquaintances. The inscription reads, "This garden is dedicated to residents whose lives in Superior, however long or short, surely contributed to our community. Although they may be interred elsewhere, their spirit lives on as an inspiration to us all." (Courtesy of Margaret Arkle Bettolo.)

The Jim Bridger Power Plant was constructed east of Superior and provides hundreds of jobs to residents of Sweetwater County. The coal-fired plant burns fuel from the Bridger Coal Mine, an underground mine, and also from Black Butte Coal, a surface mine. The plant has brought stable jobs to the area.

Discover Thousands of Local History Books Featuring Millions of Vintage Images

Arcadia Publishing, the leading local history publisher in the United States, is committed to making history accessible and meaningful through publishing books that celebrate and preserve the heritage of America's people and places.

Find more books like this at
www.arcadiapublishing.com

Search for your hometown history, your old stomping grounds, and even your favorite sports team.

Consistent with our mission to preserve history on a local level, this book was printed in South Carolina on American-made paper and manufactured entirely in the United States. Products carrying the accredited Forest Stewardship Council (FSC) label are printed on 100 percent FSC-certified paper.

MADE IN THE USA